TYPE

How to Spe

Alex White

Watson-Guptill Publications, New York
A Roundtable Press Book

How to Spec

TYPE

A Roundtable Press Book

Published by Watson-Guptill Publications
a division of Billboard Publications, Inc.
1515 Broadway, New York, NY 10036

The illustrations on pages 71, 73, 90, 99, and 115, reprinted by permission of
Step-by-Step Graphics, 6000 N. Forest Park Drive, Peoria, IL 61614, originally
appeared in Vol. 2, Nos. 1, 2, 4.

Library of Congress Cataloging-in-Publication Data
White, Alex.
 How to spec type.
 "A Roundtable Press Book."
 Bibliography p. 125
 Includes index.
 1. Printing, Practical–Style manuals. I. Title.
Z253.W46 1987 686.2'24 86-19004
ISBN 0-8230-2473-3

Printed in the United States of America
First printing, 1987
1 2 3 4 5 6 7 8 9 10 / 92 91 90 89 88 87

A handful of invaluable friends have contributed directly to the writing of this book, I would like to thank them here: my editors, Susan Meyer and Marsha Melnick of Roundtable Press, and Julia Moore of Watson-Guptill, for doing their jobs so extremely well; Don Dyer, Lynn Gouldsbrough, and the staff* at Mono Typesetting (54 Granby Street, Bloomfield, CT 203/242.3006) for their enthusiasm and spec control on the examples; Annie Brighenti for her exacting help with the mechanicals; and Meg Ross for being wonderful in keeping up with the many manuscript changes.

Others who have helped me with this book are Nancy Aldrich-Ruenzel at *Step-by-Step Graphics;* Mac Baumwell at mjb Typography; Frank Blume, Priscilla Sicard, and Phil Davieau at Eastern Typesetting Company (515 John Fitch Blvd., South Windsor, CT 203/528.9631); and Arthur Brown and Bros., Inc. (2 West 46 St., New York, NY 10036) for use of the Haberule®. And, of course, thanks must go to my students, who were the first to try out the exercises and find helpful ways of "improving the professor's work."

But most of all, I want to thank Jan White. I am proud to have been part of his numerous books' dedications. *How To Spec Type* is dedicated to my dad.

*Because this book is about typography, it must necessarily be filled with perfectly set typographic examples. At one time or another, virtually every member of Mono's staff had a hand in helping get this body of work out of my head and onto these pages. Here is a complete list of these helpful people: Jane Abed, Greg Abbott, John Amamoo, Ray Aronson, Bill Baggish, Lenny Bossak, Mr. Brown, Florence Byrne, Paul Dubbs, Herbie Hernandez, Andrew Jefferson, Andrew Jones, Chris Kozlowski, Bill Krampitz, Janice Lee, Jane Lescher, Mel Lingley, Betty Ann Lovesky, Jack Madigan, Paul Marchon, Kathy Matzak, Nancy Miner, Fred Moore, Anita Ortis, Ben Ostasiewski, Nick Paradis, Barbara Prabucki, Norm Rogers, Bob Salls, Stan Skowronek, George Sylvester, Mike Wice, Dan Wulfe, George Young.

ACKNOWLEDGMENTS

CONTENTS

Part One Preparing the Copy for Type

Part Two Type Samples

CONTENTS

Be careful. This book is a gold mine of ideas. As you go through the pages, you can't help but be inspired. In fact, if you are at all typical, you'll start making mental notes: *that's a trick I could use ... where can I stick that clever gimmick ... and what about this great concept ...* [1]

But this book is more than just a treasure trove of tricks. It is a swipefile with a difference: Not only does the book show you the ideas, **it shows you how to implement them.** [2] You can find what you "like"–what catches your fancy–and be guided through the steps of communicating the idea to your type supplier, so that you actually get what you hoped you were asking for. (That's no easy trick in itself). [3] You see the ideas here in three stages: as a thumbnail sketch, as the specced manuscript, and as the finished product. This format helps you enter the idea-finding process from any point in the production cycle.

But please don't use the book that way. [4] Whenever you work with type, always consider what you are doing, and understand *why* you are doing it, before you run headlong into specifying the type.

Typography is one of the most valuable resources of our civilization. Next to word-of-mouth (and its electronic clone on the tube), type is the primary tool of communication. In this Age of Communication, partly because there are more and more of us on this globe, we have to communicate clearly to stay sane, let alone to stay alive. The clearer, more understandable, and more effective the communication process between speaker and listener (or between writer and reader) the better for everyone involved. The signs look good. Consider just three areas of the communication field.

- [5] Currently there is a strong popular movement to elevate awareness of the English language. In almost every publication, you're likely to find an article decrying or mocking gobbledygook. Shelves bend with books on the origin of words, how to use words, how not to misuse words. Wherever you find in-house publishing activities, you'll find a book of standards defining word usage. More employers than ever are complaining that new-hires can't write a simple sentence or spell correctly. ("New-hires"! See what I mean mean about gobbledygook? That realization is the first step to improvement.)

- Look at the burgeoning revival of italic handwriting. Calligraphy–the art of beautiful writing–is slowly but steadily replacing the illegible, characterless scrawl that most people call their "hand." Adults are learning to use it because they want to be proud of the way their message appears to the recipient. You appear as what you send out under your signature. Perhaps your signature is a small and personal example. But all communication, be it spoken or written, is ultimately a personal act. Consciousness of handwriting is a valid indicator of how important print is, and print is merely the mechanical reproduction of words on paper.

- Consider the other, technological end of the communication spectrum. The pendulum of attention is now swinging back towards the art of typography and away from the mechanics of producing it. In recent times we have been mesmerized by technology: first, phototypesetting, then computerized workstations, digitized typesetting, automatic electronic page makeup, and now the manipulation of everything in full color on screen, where WYSIWYG ("What You See Is What You Get") is the ruling principle. Now you can buy a whole printing plant squeezed

[1] 10/12 ITC Cheltenham Light Italic
[2] 10/12 ITC Cheltenham Bold
[3] 7/12 ITC Cheltenham Light
[4] 10/12 ITC Cheltenham Bold Condensed

[5] 5-point bullet with 9/11 ITC Cheltenham Light indented 1 pica

into a few boxes from which you can actually set up an entire desktop publishing center. But there is a growing realization that the end purpose of these marvels of technology is greater than the machines themselves. Their output has to be good, not just fast. Rightly, the attention is shifting away from the machines and how they are used to what their wonders should be used *for.*

Typography must be seen in this broader context of quality communication, and that is why the array of ideas shown in this book are not just clever graphic tricks. They are the ***ingredients of a visual language.***[6] The ideas are valuable because they enrich visual language with their variety. They help to create mood and feeling. They add color and interest. And clarify thought.

Tone-of-voice typography[7]

What a bore it is to listen to a monotonous speaker. You force yourself to stay awake because if you fall asleep you might miss some nugget of wisdom buried in that mass of dreary slag. In fact, insipid delivery compels you to concentrate and *work.*

On the other hand, a canny speaker makes it easy for you to recognize those golden bits of value. The voice provides the clues. Loudness is the cue to the importance of the meaning behind the words, and so is the pitch of voice–which ranges from squeaky highs to rumbly lows. Modulation is what keeps the listener interested. Unexpected contrasts startle you, keep you alert. If the thoughts are logically organized, the delivery can make that organization transparent and the contained information more readily accessible.

*What is the type specification for a **boring** speech?*[8] How about 10/11 Helvetica × 21 picas (like running text set in two columns on a magazine page)? No expression. No variation. No emphasis. No color. Just pale gray column after pale gray column of neat and precise text, mumbling on page a f t e r p a g e .[9]

*What is the type specification for a **lively** speech?* There is no reason why you cannot use the same 10/11 × 21 Helvetica. This is a marvelous face and an excellent specification in just that size and proportion. But that is only where the specification *begins:*

- Just as the voice adds emphasis to important words, so can type:
 It shouts or whispers by variation of size.[10]

- Just as the pitch of the voice adds interest to the words, so can type:
 It modulates by lightness or **darkness.** [11]

- Just as the voice adds color to the words by inflection, so can type:
 It defines *elegance,* dignity, **toughness** by choice of face.[12]

Type is as rich and as flexible as the human voice. Its infinite variety is capable of paralleling the most subtle vocal expression. Type is visually just as colorful as the voice, just as full of accent and impact, color and tonalities as its audible counterpart. Type can whisper or it can shout. It can sing or croak from the highest *soprano* to the deepest basso profundo. Type can be musical or discordant, dull or lively, smooth or harsh, beautiful or ugly. It can be inspiring and reach the level of fine

[6]10/12 ITC Cheltenham Bold Italic
[7]14/12 ITC Cheltenham Bold

[8]10/12 ITC Cheltenham Light Italic with Bold Italic
[9]Letter and word spacing increased by 1 point per space
[10]10-point Helvetica with 18-point and 6-point highlights
[11]10-point Helvetica with Light and Black highlights
[12]10-point Helvetica with 12-point ITC Novarese Book Italic, ITC Garamond Light, and ITC Eras Ultra

art or merely reflect unthinking formulas. Its potential is limitless.

Using type well

There is no such thing as "right" or "correct" use of type. There is only vivid and eloquent effectiveness, or numbing and misleading ineffectiveness. The way to exploit type most effectively depends on the specifics of the project at hand. A math textbook clearly requires a very different approach from that applied to a small-space classified advertisement, or to a label for a beer can. Though they all carry verbal messages in type, their purposes, physical attributes, and audiences are totally different. What is right for one is likely to be wrong for the others. The one thread that runs through all typographic possibilities is **utility.**

Does the way the type is handled in a specific circumstance fulfill its purpose? Is it doing the job efficiently? Is the message coming through clearly and vividly? Is the message jumping off the page into the reader's mind crisply and memorably? Put another way, in the form of a checklist, is the type

actively helping?	☐
neutral?	☐
actively hindering?	☐ [13]

If it is actively helping, *the message has been given its optimal shape.*
If it is neutral, *the type is following hackneyed, undistinguished formulas.*
If it is hindering, *it is pulling attention from the message itself.*

If the form of the typography grows organically out of the verbal content – if the visual character fits the meaning of the words and if the visible shape conforms to the inner structure of the writing – then the result is bound to be vivid and understandable. Typographic nuances should be used to enhance and clarify the visual expression of the message, whatever that message might be. Good typography is transparent, like blister-packaging – exposing the content inside and letting it speak for itself. Yet too often typography is used like gift wrapping, in the hope that cosmetic prettification will make the package seem more desirable. Gift wrapping confuses because it camouflages the reality wrapped inside. At first glance, the piece may catch the viewer's attention because it looks graphically beguiling: "Hey, that looks nice. Maybe it's worthwhile getting into!" The packaging may be clever salesmanship, but the true test of typographic excellence is what follows the first attention-catching stage. Ultimately the piece has to deliver on its implied promise. The viewer quickly discovers if the voguish look is phony, merely a disguise. Simply looking fashionably exciting is not enough. The ensuing disappointment – if not anger – is probably more detrimental to the source's reputation in the long run.

Typography can indeed be raised to the level of art. Nevertheless, typography is first and foremost **a utilitarian craft applied for a purpose other than itself.** The danger lies in thinking of it as an art form first, and a means of communication second, when typography is, in fact, both simultaneously. You cannot separate the form from its content, arranging the marks on paper in some preconceived abstract arrangement,

[13] 7-point ballots flush right with ½-point ruled leaders across 14-pica column

because the marks are words, and words carry meaning. The arrangement and the meaning of these words must make sense together. Although design based on aesthetic considerations is one important aspect of the art of typography, it must not be allowed to be dominant.

By basing typographic arrangement on purely abstract aesthetic principles, you run the danger of mindlessly applying formulas and axiomatic beliefs without regard for the specific needs of the individual project. You must search the manuscript for its significance and meaning, so that you can devise the most revealing typographic format for it. The content – not abstract theories of aesthetics or style – should dictate the form.

That is why the typographic form-giver (designer, art director, writer, editor, typesetter, printer) must first **read the message.** It is not enough just to count the characters in the manuscript and figure out a spec to make it fit the prescribed space. The message has to be read, absorbed, and its mean-

ing understood, to ensure that its structure is logically expressed and important ingredients emphasized. That is why it is so important for a close, intimate, intellectual partnership to exist between the word-people and the visual people: their efforts must be blended if their product is to communicate vigorously.

Good typography links the verbal with the visual to produce arresting results. Good typography clarifies. It articulates. It elucidates. It expresses *meaning*.

So don't use this book as a collection of clever type tricks and how to spec them. Perceive it, instead, as a treasury of visual/verbal techniques with which to upgrade and enrich the value of printed communication.

Typography is language. Open your eyes and listen.

Jan V. White

 little knowledge is *not* a dangerous thing. Except maybe when you're a passenger in a friend's private plane. Then you don't want to know that the wings are also the fuel tanks, or that the little red spot on the storm radar indicates severe electrical activity two miles ahead. In many other areas of everyday life, a little knowledge is indeed a wonderfully comforting thing.

Specifying type is like that. Having a good, solid understanding of just a few principles (plus the application of common sense) will get you through nearly any type speccing problem, no matter how dissimilar previous problems may appear at first glance.

Speccing type is a process that definitely *looks* complex. However, each step in the process is completely logical. There are many odds and ends to think of as you specify type, and this book will familiarize you with these details.

The process of speccing type consists of two main activities: copyfitting and tracing from sample books. Tracing is used primarily for display, or large-sized type. Copyfitting, on the other hand, is the process of estimating the amount of space typewritten copy will occupy once it has been set in type. Ordinarily, copyfitting implies text, or small-sized type.

Copyfitting is the area most designers try to avoid because it makes them feel confused. I think that what produces such a common dislike for this necessary and integral part of design (our business) is the idea of working with numbers—plain old *math*. To prove the point, you can buy one of a dozen or more devices and gadgets—some costing hundreds of dollars—that purport to make type speccing easier. All of these devices are designed to "simplify" the math. But if you can

add, subtract, multiply, and divide, and if you know how to use the simplest calculator, you can wend your way through virtually any speccing problem that comes along.

Computers have made an enormous impact on the typesetting industry in the past twenty years. Current technology can provide an instant character count as soon as the copy has been entered as raw manuscript. This information can then be adapted to prioritized guidelines the art director has already established. The typesetter achieves a tailor-made fit by adjusting the client's guidelines. Although the flexibility offered by such computers is staggering, you may not like to have these decisions made by proxy, facing the prospect of a second pass through the computer, thereby incurring a second typesetting charge.

More and more of these extraordinary and complex digital typesetters are managed by computer operators, who necessarily know a lot about coding and keyboarding, but who may not share your sensitivity toward typography. I believe good art directors want maximum control over each of their projects, and this book is intended to help all designers become more able to specify and obtain precisely what they envision in their comps.

How to Spec Type is prepared for widest use: its techniques are proven to work, regardless of your typesetter's equipment and capabilities. There are, however, other methods of determining a typespec. For example, a technique called the "300 Equation" determines text area in square picas. It works by multiplying factors (line length, depth, type size, leading, and number of characters) and then dividing the result by $144 \times$ the character-per-pica figure for any 12-point typeface.

It is called the "300 Equation" because 300 is the average result of the $144 \times$ CPP determination. This system, and others like it, represent atypical methods of specifying type and are therefore omitted from a book dealing with more conventional approaches.

This book is divided into two parts. *Part One: Preparing the Copy for Type,* discusses fundamental terms and introduces the principles of type speccing. *Part Two: Type Samples,* describes how to spec typographic examples drawn in thumbnail form, how to mark up the manuscript copy, and then shows the final typeset results. The manuscript copy has been reduced in *Part Two* by 25%, but otherwise all examples are shown actual size.

My intention is that this book not be used as a mere typographic swipefile. Rather, it should stimulate a flow of ideas by application of the principles shown in the examples to your particular design needs. There are, after all, an unending number of executions to the basic themes illustrated here. *How to Spec Type* should broaden your perspective of typography, not merely substitute my vision for yours.

Because design is in a constantly evolving state, in the years to come some of the examples may look dated to you, or perhaps you may find some examples more aesthetically pleasing than others. My hope is that, in their fundamental state, all the examples will float on the surface of the ebb and flow of temporary design trends.

Part One:
Preparing the Copy for Type

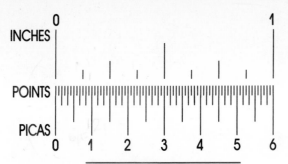

There are 12 points to a pica
and almost 6 picas to an inch
(72 points to an inch).

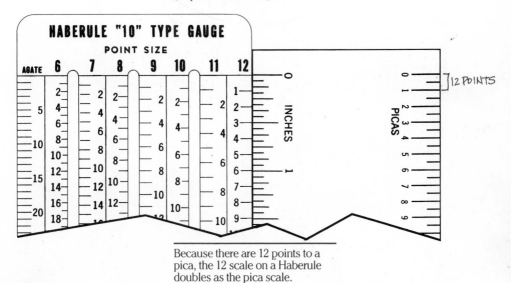

Because there are 12 points to a
pica, the 12 scale on a Haberule
doubles as the pica scale.

What, art thou drawn among these heartless hinds?

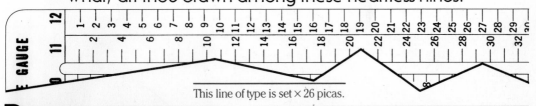

This line of type is set × 26 picas.

POINTS AND PICAS

All type measurements are described in units called **picas** and **points** (abbreviated pi and pts.). We say that 6 picas equal one inch. There are 12 points to one pica. Being the smallest unit of measurement, points are usually used to describe the height of type. Being the larger unit of measurement, picas are used to describe line lengths. A line measuring 30 picas is written × 30 and is read "by 30."

A Haberule® is a tool used to measure type. It contains scales that indicate various increments of space, and later you will learn how to use it.

An item worth noting: While it's okay to say that 6 picas equal an inch, they don't really. Actually, 6 picas measure only .9961 inch, a discrepancy that becomes evident on dimensions over 10 inches.

15

Origin of the term *x-height*

x-height — no ascenders or descenders

Letters with ascenders

x-height

b d f h k l t

mean line

baseline

Letters with descenders

x-height

g j p q y

mean line

baseline

H. M. Charles VI

Serif type

H. M. Henry V

Sans serif type

LANGUAGE OF TYPE

The **x-height** of a lowercase (or small) letter is the vertical dimension of the letter between the so-called **mean line** and the **baseline.**

 Ascenders are the parts of lowercase letters that stick up above the mean line, and **descenders** are the parts of letters that hang below the baseline.

 There are two basic kinds of letterforms: serif and sans serif. **Serifs** are the little feet at the ends of strokes of letters. Serifs create a consistent horizontal direction at the ends of strokes.

 Sans is the French word for *without.* **Sans serif** type is therefore type without serifs. Notice that sans serif type does not tend to show the same contrast of thick and thin strokes found in serif type.

Cheltenham Light
Cheltenham Light Italic
Cheltenham Book
Cheltenham Book Italic
Cheltenham Bold
Cheltenham Bold Italic
Cheltenham Ultra
Cheltenham Ultra Italic
Cheltenham Light Condensed
Cheltenham Light Condensed Italic
Cheltenham Book Condensed
Cheltenham Book Condensed Italic
Cheltenham Bold Condensed
Cheltenham Bold Condensed Italic
Cheltenham Ultra Condensed
Cheltenham Ultra Condensed Italic

The complete ITC Cheltenham family

ABCDEFGHIJKLMNOPQRSTUVWXYZ	Caps	
abcdefghijklmnopqrstuvwxyz	Lowercase	
ABCDEFGHIJKLMNOPQRSTUVWXYZ	Small caps	
æ Æ Œ œ fi fi ff ffi ffl	Ligatures	
1234567890	Numerals	
⅓ ⅔ ¼ ½ ¾ ⅕ ⅖ ⅗ ⅘ ⅙ ⅚	Fractions	
' " ! " , . ? ¡ « ' " " » ¿	Punctuation marks	
@ # $ % ^ & · 0 − + = { [}]	/ < > ™	Dingbats and symbols
§ ▪ ♂ ‡ ♠ ă ¯ ç ° ○ Ø Å Ç		

The complete font of ITC Cheltenham Light,
shown in 10 point

17

A **font** contains all the characters of a particular typeface, which can include all uppercase (capital or caps) and lowercase letters and small caps. A font also includes ligatures (joined letters), figures, fractions, punctuation marks, and symbols. There can be from 26 to possibly 450 characters in a complete font.

A type family is made up of a series of fonts, generally including regular, light, bold, extra bold, italic, condensed, and expanded faces. A type family can include additional variations such as outline and contour faces.

Bolingbroke

x-height | point size of type

60-point ITC Quorum Bold

Ophelia Ophelia Ophelia

Three 36-point typefaces. Each *appears* to be a different size because of different x-height.

a I must dance barefoot on her wedding day, and, for your love of her, lead apes in hell.

d I must dance barefoot on her wedding day, and, for your love of her, lead apes in hell.

b I must dance barefoot on her wedding day, and, for your love of her, lead apes in hell.

e I must dance barefoot on her wedding day, and, for your love of her, lead apes in hell.

c I must dance barefoot on her wedding day, and, for your love of her, lead apes in hell.

f I must dance barefoot on her wedding day, and, for your love of her, lead apes in hell.

Most of the examples above are 10-point type. Can you identify the two 9-point samples? It is the apparent size of a typeface that is important, and this is based to a great extent on the size of the x-height.

Answer: a, c, e, f = 10 point
b, d = 9 point



TYPE SIZE

18 | TYPE SIZE

According to traditional practice, type size is identified in points. Ideally, the **point size** of a typeface should be determined by measuring the vertical distance from the tops of the ascenders to the bottoms of the descenders, and many contemporary typesetting systems are standardizing this practice. But this dimension may not always be an accurate indication, so don't rely on it. Your best guide is seeing a type sample.

Even if the distance between ascenders and descenders is the same among typefaces, their x-heights will cause one face to *appear* larger or smaller than another. A 10-point typeface with a large x-height looks bigger than a 10-point typeface with a small x-height.

Traditionally, **display type** refers to type 18 points and larger, while smaller type is called **text type.**

Cheltenham Light
Cheltenham Book
Cheltenham Bold
Cheltenham Ultra

Type weight

Cheltenham Book
Cheltenham Book Italic

Type posture

I myself have all the other, and the very ports they blow, all the quarters that they know i' the shipman's card. I will drain him dry as hay: sleep shall neither night nor day hang upon his pent-house lid; he shall live a man forbid: weary se'nnights nine times nine shall he dwindle, peak and pine: though his bark cannot be lost, yet it shall be tempest-tost.
Book Look what I have.

I myself have all the other, and the very ports they blow, all the quarters that they know i' the shipman's card. I will drain him dry as hay: sleep shall neither night nor day hang upon his pent-house lid; he shall live a man forbid: weary se'nnights nine times nine shall he dwindle, peak and pine: though his bark cannot be lost, yet it shall be tempest-tost. Look what I have.
Bold

I myself have all the other, and the very ports they blow, all the quarters that they know i' the shipman's card. I will drain him dry as hay: sleep shall neither night nor day hang upon his pent-house lid; he shall live a man forbid: weary se'nnights nine times nine shall he dwindle, peak and pine: though his bark cannot be lost, yet it shall be tempest-tost.
Book italic *Look what I have.*

Bold always runs longer than regular setting, while italic and roman generally run about the same length.

WEIGHT AND POSTURE

Type families come in variations of weight and posture, as you have already seen. **Weight** varies from light to heavy (bold), while **posture** describes the angle. (Vertical equals roman, slanted or oblique equals italic.)

When specifying type, always write the weight and/or posture after the name of the face. For example, 10-point Cheltenham Bold, or 10-point Cheltenham Light Italic.

Shown above are three examples of the same family set in the same point size. Note that each variation occupies a different amount of space.

19

Touching/Overlap	**proveth**
Very tight	**proveth**
Tight	**proveth**
Normal	**proveth**
Open	**proveth**

Normal	Having nothing, Nothing can he lose.
Tight	Having nothing, Nothing can he lose.
Open	Having nothing, Nothing can he lose.

AT AY AV AW LT LY LV PA TA VA WA YA
 Ay Av Aw Ly Lv P. To Va Wa Ya
 Tr Yo
 T. Y.

Kerning: Each of the letter pairs above has been tucked closer together.

20 LETTERSPACING

Letterspacing refers to the spaces between letters. Letterspacing must allow individual character recognition and should appear consistent to the eye.

A typesetter can adjust the space between all letters of a word according to your specifications, which you can indicate as shown above. Or ask for the typesetter's own marking directions.

Kerning is removing space between certain characters to tighten their fit with adjacent letters. When tucked closer together, these letters *appear* to have the same letterspacing that exists between the other letters in the word. The letter pairs that require kerning the most often are shown in the chart above.

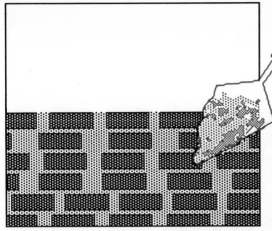

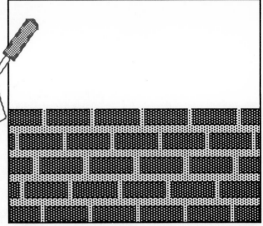

A little fire is quickly trodden
out; which, being suffered, and
suffered badly, rivers cannot quench.

A little fire is quickly trodden out; which,
being suffered, and suffered badly, rivers
cannot quench.

These bricks have more mortar on the sides than they
do above and below: The eye wants to travel down the
chunks of mortar. The rows of bricks appear to be
vertical stacks.

These bricks have more mortar above and below than
they do between them. The rows of bricks appear as
horizontal layers.

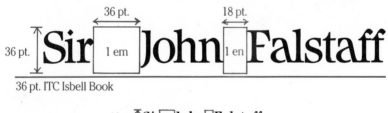

36 pt.

36 pt.

18 pt.

36 pt. Sir 1 em John 1 en Falstaff

36 pt. ITC Isbell Book

12 pt. Sir John Falstaff

1 em:
12 pt. × 12 pt.

1 en:
6 pt. × 12 pt.

12 pt. ITC Isbell Book

The size of ems and ens is determined by the point size of the type being used.

WORD SPACING

Word spacing refers to the spaces inserted be-
tween words. Just as letters need sufficient space
for their edges to be read, words need space sepa-
rating them from one another. Like letterspacing,
word spacing should not be so pronounced that it
is noticeable.

　　If you think of words as bricks and word
spacing as mortar, you can see you need only
enough mortar to cement the bricks together
(and no more).

　　For spacing at paragraph indents, indicate
the amount of space by using either **em** or **en**
spaces (see page 45). An em is a unit of measure-
ment that is the square of the point size of the type
being used. For example, an em in a 12-point face
is 12 points wide by 12 points high. An en is half
the width; in a 12-point face it is 6 points wide by
12 points high.

21

King
Henry

Leading appears between ascenders and descenders.

Top of ascender to bottom of descender is type's point size (in this case, 48 pt.)

3 pt.

48 pt.

Baseline to baseline . . . 51 pt.
minus type size − 48 pt.
yields leading 3 pt.

The eye of man hath not heard, the ear of man hath not seen, man's hand is not able to taste, his tongue to conceive, nor his heart to report, what my dream was.

10/10 ITC Cheltenham Book

The eye of man hath not heard, the ear of man hath not seen, man's hand is not able to taste, his tongue to conceive, nor his heart to report, what my dream was.

10/12 ITC Cheltenham Book

The eye of man hath not heard, the ear of man hath not seen, man's hand is not able to taste, his tongue to conceive, nor his heart to report, what my dream was.

10/14 ITC Cheltenham Book

22 | LINE SPACING

Line spacing refers to the amount of space inserted between lines of type. It is also called **leading** (pronounced "ledding") because when metal type was commonly used spaces between lines were created by inserting pieces of lead between rows of type.

Leading is measured from baseline to baseline, or b/b, and is indicated in points. For example, 10 point Cheltenham with 2 points of space between lines is written as 10/12 Cheltenham.

Four points of space would be written as 10/14 Cheltenham. These instructions are read as "10 on 12" and "10 on 14" Cheltenham. When no leading is inserted, we say "10-point Cheltenham solid," which is written as 10/10 Cheltenham.

I'll say you grey is not the morning's eye, 'tis but the pale reflex of Cynthia's brow; nor that is not the lark, whose notes do beat the vaulty heaven so high above our heads: I have more care to stay than will to go: come, death, and welcome: Juliet wills it so.

I'll say you grey is not the morning's eye, 'tis but the pale reflex of Cynthia's brow; nor that is not the lark, whose notes do beat the vaulty heaven so high above our heads: I have more care to stay than will to go: come, death, and welcome: Juliet wills it so.

Longer lines need more line spacing.

Let us do so: for we are at the stake, and bay'd about with many enemies; and some that smile have in their hearts, I fear, millions of mischiefs.
10/10 Antique Olive

Let us do so: for we are at the stake, and bay'd about with many enemies; and some that smile have in their hearts, I fear, millions of mischiefs.
10/10 Futura Medium

Large x-heights need more line spacing than small x-heights. The example above appears to be much tighter than the example on the right, although both are the same size and have the same leading.

The grass stoops not, he treads so light.

30 pt.
30 pt.
30 pt.

30/30 ITC Isbell Bold (set solid)

The grass stoops not, he treads so light.

26 pt.
26 pt.
26 pt.

30/26 ITC Isbell Bold (minus leading)

LINE SPACING

23

The legibility of longer lines is enhanced when line spacing is increased, because it provides the eye with a clearer path of return to the beginning of a column. Typefaces with larger x-heights tend to require more leading than those with smaller x-heights.

Minus leading is setting type so that ascenders and descenders can possibly overlap. Removing space between lines makes reading text difficult and should be avoided. It is, however, very effective for display type. Condensing the amount of space in which a headline sits can increase the impact of the headline. At display sizes, be sure letters are clearly distinguishable even when ascenders and descenders touch. It is best to avoid problems with minus leading by arranging headlines so that ascenders and descenders are not located vertically in the same spot.

Instructions for minus-leaded type are written, for example, as 30/26.

Like one that stands upon a promontory, and spies a far-off shore where he would tread, wishing his foot were equal with his eye, and chides the sea that sunders him from thence, saying, he'll lade it dry to have his way.

12/13 × 18
Palatino
Justified

Justification used well: About 39 characters per line give optically consistent word spacing.

Like one that stands upon a promontory, and spies a far-off shore where he would tread, wishing his foot were equal with his eye, and chides the sea that sunders him from thence, saying, he'll lade it dry to have his way.

12/13 × 11
Palatino
Justified

Justification used poorly: Too few characters per line produce uneven word spacing from line to line.

Like one that stands upon a promontory, and spies a far-off shore where he would tread, wishing his foot were equal with his eye, and chides the sea that sunders him from thence, saying, he'll lade it dry to have his way.

12/13 × 18
Palatino
fl l/rag r
no hyphens

Flush left/ragged right: The ragged right edge permits consistent word spacing.

24 TYPE ARRANGEMENTS

There are five ways of arranging type (also called column structure) on the page. The five ways are justified; flush left/ragged right; flush right/ragged left; centered; and asymmetrical.

Justified type is even, or **flush,** on both edges. The neat, squared-off look of justified type comes at the expense of forcing variable word spacing in each line. When there are too few characters per line, the word spacing can become too open because words must be stretched to reach the left and right margins. As a rule of thumb, it is wise to maintain a minimum column width of 39 characters (one and a half alphabets) to prevent peculiar word spacing. To specify justified type, write either fl l/r or justify.

Like one that stands upon a promon-
tory, and spies a far-off shore where
he would tread, wishing his foot were
equal with his eye, and chides the sea that
sunders him from thence, say-
ing, he'll lade it dry to have his way.

12/13 × 18
fl r/rag l
hyphenate
Palatino

Flush right/ragged left: Word spacing is consistent but
reading is difficult because of the uneven left edge.

Like one that stands upon a promontory,
and spies a far-off shore where he
would tread, wishing his foot were equal
with his eye, and chides the sea
that sunders him from thence, saying,
he'll lade it dry to have his way.

12/13 × 18
centered
no hyphens
Palatino

center line

Centered: Ragged left and right edges permit consistent
word spacing; always break lines to get dramatically
unequal lengths so it looks like it's *supposed* to be set
that way.

Like one that stands

upon a promontory,

and spies a far-off shore

where he would tread,

wishing his foot

were equal with his eye, and chides the sea

that sunders him from thence,

saying, he'll lade it dry

to have

his way

12/15 × 18
fl l/rag r
line for line
no hyphens
Palatino

Asymmetrical: Forces the reader to participate; have the copy set with extra leading to make it easier
to cut up and paste in position.

25

Flush left/ragged right type is considered to
be the easiest arrangement for the eye to read.
Word spacing remains constant and there is an
even left edge to return to after every line. Specify
whether you want to hyphenate words; no
hyphenation results in a more ragged edge
because whole words are dragged down to the
next line. Specify as fl l/rag r or fl/rr.

 Flush right/ragged left type is more diffi-
cult to read because the eye must search for the
next line's beginning. It is used primarily for cap-
tions. Specify as fl r/rag l or fr/rl.

 Centered type has the same drawback as
fl r/rag l type: no clean left edge for the eye to
return to. Specify as centered.

 Asymmetrical type is reserved for poetry
and special situations. Because it's difficult to
spec, you'll find it easier to set the copy line for
line, then cut it apart and position it yourself on
the mechanical.

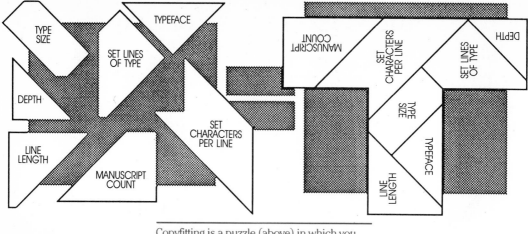

Copyfitting is a puzzle (above) in which you must fit the seven pieces together to get set type, as shown below.

In this case, we already know the manuscript contains 891 characters. We see from this accurate rendering (or comp) that the line length is 28 picas, there are 12 points b/b in 13 lines for an overall depth of 2⅛ inches, and we have already selected ITC Garamond Light as our typeface. The only pieces of the puzzle still unknown are the size of the type and the number of characters per line this face will set.

COPYFITTING

The process of estimating the amount of space typewritten copy will occupy when converted into type is called **copyfitting.** It is very much like solving a puzzle, where you are able to identify some pieces and must use what you know to find what's missing.

In copyfitting, there are a limited number of pieces. They are the manuscript character count; typeface; type size; line length; set characters (typeset letterforms) per line; number of set lines of type; and column depth. That's seven pieces of the puzzle to juggle. For example, you might know how long your manuscript runs, but you don't know how much space the column will occupy when converted to type. Or you know your manuscript count and have a fixed space to fit it in, but don't know what type size to use.

Step 1: Count **manuscript characters.** (Include word spaces, punctuation, one character at the end of each line, extra spaces for indents.)

Step 2: Select **typeface** and **type size** you want.

Step 3: Cast off to determine number of **set characters** per line. (How long is the line?)

Step 4: Divide set characters per line into total manuscript character count. Result is number of **lines** of set type.

Step 5: Add **leading** to taste.

Step 6: **If too short:** add leading or increase type size or decrease line length.

If too long: remove leading or decrease type size or increase line length.

There are six simple steps to copyfitting. If you follow them carefully, you'll have a custom fit every time.

The first step is to calculate the number of typewritten characters in the manuscript. Then you translate the number of characters into a specific typeface in the size and width required for the layout.

At first you will have to consciously consider all the pieces of a copyfitting puzzle to find what's missing. After a little practice, you'll be able to indentify the missing pieces instinctively. It is at this point that copyfitting will no longer seem like a chore.

To be, or not to be: that is the 33

Each character, punctuation mark, and space counts as one character.

To be, or not to be: that is the 33
question: whether 'tis nobler in 33
the mind to suffer the slings and 34
arrows of outrageous fortune, or 33
to take arms against a sea of 30

$163 \div 5 = 33$ average
manuscript
characters
per line

How to count characters per line with variable spaced copy: Total up the number of characters in five typical lines and divide by five for a single line's average character count. With averaging, you may be off by as much as 10 percent, so always calculate on the high side to play it safe.

28

COUNTING CHARACTERS

To count characters, first determine whether the text was prepared on a monospace or variable space typewriter or word processor. A **monospace** device gives every character exactly the same amount of space, either 10 characters per inch (pica) or 12 characters per inch (elite). A **variable space** device gives each character individual spacing according to its specific shape—for example, more space for *M* than for *i*.

Monospaced copy is easy to count. Because every character, punctuation mark, and space is the same size, a given line length will always contain the same number of characters. Proportionally spaced copy makes accurate character counting more difficult. Count the characters in five typical lines and divide the total by five to get an average per-line character count.

1 Draw a vertical rule at the end of an average line (halfway between longest and shortest lines).

2 Count all the characters and spaces from the left edge to the vertical rule (in this case, 31 characters).

Count one space at the end of each line; it would be a word space if the line continued.

Count two spaces after the end of a sentence.

Count two spaces for a paragraph indent.

Do not count spaces at the end of a paragraph; they are inconsequential because they won't be occupied by set type.

```
To be, or not to be: that is the    +2
question: whether 'tis nobler in    +2
the mind to suffer the slings and   +3
arrows of outrageous fortune, or    +2
to take arms against a sea of         -1
troubles, and by opposing end         -1
them? To die: to sleep; no more;    +3
and by a sleep to say we end the    +2
heart-ache and the thousand           -3
natural shocks that flesh is heir   +3
to, 'tis a consummation devoutly    +2
to be wish'd.                        -18
 To die, to sleep; to sleep:          -1
perchance to dream: ay, there's     +1
the rub; for in that sleep of         -1
death what dreams may come when     +1
we have shuffled off this mortal    +2
coil, must give us pause: there's   +3
the respect that makes calamity     +1
of so long life; for who would
bear the whips and scorns of time,  +4
the oppressor's wrong, the proud    +2
man's contumely, the pangs of         -1
despised love, the law's delay,     +1
the insolence of office and the     +1
spurns that patient merit of the    +2
unworthy takes, when he himself     +1
might his quietus make with a         -1
bare bodkin?                         -19
                                    +38 -46
```

3 Multiply the characters-per-line count by the total number of lines:
$29 \times 31 = 899$

4 Add the characters that exceed the vertical rule:
$899 + 38 = 937$

5 Subtract the characters in lines that fall short of the vertical rule:
$937 - 46 = \mathbf{891}$

Total manuscript character count

COUNTING MANUSCRIPT

Determine the total number of characters in the copy by laying a ruler along the right edge of a typical line length and lightly drawing a vertical rule in pencil. Count the characters to the left of the vertical rule. Multiply this characters-per-line figure by the number of lines in the manuscript (29 here). Add all the extra characters to the right of the vertical line, including one space at the end of each line for the word space that would exist if the line continued. Then subtract the empty spaces to the left of the vertical line. Our total above is 891 characters.

Longer manuscripts can be estimated by multiplying the first page's character count by the number of pages in the manuscript. Remember to adjust if all pages are not equivalent in length.

ABCDEFGHIJKLMNOPQRSTUVWXYZ 9
abcdefghijklmnopqrstuvwxyz
0123456789

Fine typography is the result of nothing more than an attitude. Its appeal comes from the understanding used in its planning; the designer must care. In the

ABCDEFGHIJKLMNOPQRSTUVWXYZ 10
abcdefghijklmnopqrstuvwxyz
0123456789

Fine typography is the result of nothing more than an attitude. Its appeal comes from the understanding used in its planning; the designer must

ABCDEFGHIJKLMNOPQRSTUVWXYZ 11
abcdefghijklmnopqrstuvwxyz
0123456789

Fine typography is the result of nothing more than an attitude. Its appeal comes from the understanding used in its planning; the de-

ABCDEFGHIJKLMNOPQRSTUVWXYZ 12
abcdefghijklmnopqrstuvwxyz
0123456789

Fine typography is the result of nothing more than an attitude. Its appeal comes from the understanding used in its plan-

Every type spec book is different because it is produced by a particular typesetter. The example shown here is a page from a typical book and contains the information you might expect to see. The numbers in the little drawings (which are the bottom ends of type gauges) tell you the average number of set characters that will fit in one pica. They get smaller as the type's point size increases, because fewer large characters fit in the same space as small characters.

30 SELECTING THE TYPE

You'll need a type specimen book for working with type. **Spec books** or "showings" are supplied by typographers and provide a catalog of the faces available from that particular source. In a spec book you'll be able to see a sample of the face desired, identify its complete name, and determine its technical characteristics—the number of characters that will fit within a given width.

Spec books provide a chart for each typeface. Once you have a manuscript character count, you can look on that chart for a characters-per-pica or characters-per-line figure. Having this figure is essential for the next step.

Fie, fie! unknit that threatening unkind brow, and dart not scornful glances from those eyes, to wound thy lord, thy king, thy governor: It blots thy beauty as frosts do bite the meads, confounds thy fame as whirl-winds shake fair buds, and in no sense is meet or amiable. A woman moved is like a fountain troubled, muddy, ill-seeming, thick, bereft of beauty; and while it is so, none so dry or thirsty will deign to sip or touch

Sample of ITC Garamond Light

ITC Garamond Light

type point size	6	7	8	9	10	11	12	14	16	18
char/pica	4.2	3.7	3.4	3.1	2.8	2.5	2.3	2.1	1.9	1.7

Multiply this chart's figures by the line length to get the characters per line: 28 pi × 2.5 char/pi = 70 set char/line

11-point ITC Garamond Light

line length in picas	8	9	10	11	12	13	14	15	16	17
char/line	20	22.5	25	27.5	30	32.5	35	37.5	40	42.5

This chart already shows the set characters per line. To determine longer line lengths not shown on the chart, add lengths: 14 pi + 14 pi = 28 pi (70 char/line)

$$891 \div 70 = 12.72$$

| manuscript character count | ÷ | set char/line | = | number of set lines |

How to determine the number of set lines of type

CASTING OFF

Now you are ready to determine if our count of 891 characters will fit the 28-pica-wide layout when converted to set type. This process is called **casting off.**

Spec books contain one of two charts. One shows how many set characters fit per pica (CPP), which you then multiply by the line length. This chart gives the CPP for several point sizes. The other chart shows how many set characters fit per line length; the CPP has been multiplied out. This chart gives the character count for line lengths in only one type size.

Select 11-point ITC Garamond Light as an example. Using either chart, you'll see that 28 picas yield 70 set characters per line. If you divide 70 into 891 characters, you get 12.72 lines of set type, which is rounded up to 13. Now, with a Haberule, determine how deep this runs.

CASTING OFF

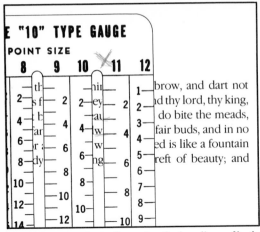

E "10" TYPE GAUGE

POINT SIZE

8	9	10	11	12

brow, and dart not
d thy lord, thy king,
do bite the meads,
fair buds, and in no
ed is like a fountain
reft of beauty; and

E "10" TYPE GAUGE

POINT SIZE

8	9	10	11	12

w, and dart not
y lord, thy king,
bite the meads,
buds, and in no
s like a fountain
of beauty; and

Note how, regardless of type size, the baselines of both type samples align perfectly on the 11 scale. While you can't determine type size, you now know the type is set on 11 points of space (?/11).

HABERULE "10" TYPE GAUG

POINT SIZE

AGATE	6	7	8	9	10	1

Fie, fie! unknit that threaten
scornful glances from those
thy governor: It blots thy be
confounds thy fame as whirl
sense is meet or amiable. A
troubled, muddy, ill-seemin

You can double all Haberule scales for larger point sizes: The 7 scale becomes the 14 scale; the 8 scale becomes the 16 scale. To determine leading on a doubled scale, simply halve the number of units; 2 units on the 8 scale become 1 unit on the 16 scale. The example shown above is set in 14/16. The 8 scale gives a reading of 12 units deep, but you halve that to find there are 6 16-point units.

sidebar

USING A HABERULE

32 USING A HABERULE

The Haberule is ideal for copyfitting. Since points are so small (72 in an inch), the Haberule simplifies measuring by grouping points into clusters. On the 11 scale, each unit (1, 2, 3, and so on) contains 11 points of space. Therefore, 3 units on the 11 scale equal 33 points; 3 units on the 10 scale equal 30 points. (Remember, the 12-point scale is also a pica scale because there are 12 points–one pica–in each of its units.)

Although the Haberule will not indicate the size of a type sample, it does indicate the space between baselines. The type can be smaller (9/11) or larger (11/11), but the baselines will register equally on the 11 scale. The baselines of the samples shown at top align only with the 11 scale, not with any other.

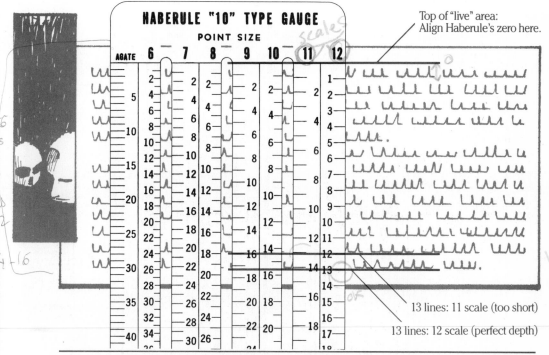

HABERULE "10" TYPE GAUGE

POINT SIZE

Top of "live" area:
Align Haberule's zero here.

13 lines: 11 scale (too short)

13 lines: 12 scale (perfect depth)

Aligning the topmost rule (the zero on all the scales) with the top of the "live" area of type, read the scale that would set your type with no additional leading (the 11 scale here). Then check progressively larger scales until you find the one that matches the set line count closest to the allowable depth. The 12 scale matches the comp perfectly; thus the correct setting would be 11/12.

ADDING LEADING

Returning to the example, you can now determine if the 13 lines of set type fit the layout. With the Haberule, follow the instructions outlined above. This problem can also be solved mathematically. The layout is 156 points deep. You have 13 lines of typeset copy that must fill 156 points, so you divide 156 by 13 to get 12 points. This means that 13 lines of 11-point type will fill the area if 1 point of leading is added to each line (11/12).

Line spacing can be determined in half-point increments. To determine half-point line spacing with the Haberule, find the midpoint between the same line depth on two scales. Note that there is a difference between where 13 lines fall on the 11 and 12-point scales. Halfway between them is the spot where 13 lines would fall if there were an 11½-point scale.

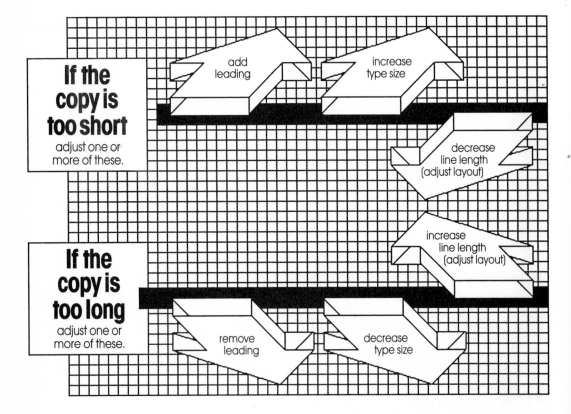

If the copy is too short
adjust one or more of these.

add leading

increase type size

decrease line length (adjust layout)

increase line length (adjust layout)

If the copy is too long
adjust one or more of these.

remove leading

decrease type size

34 ADJUSTING TO FIT

If casting off reveals that the type will run too long or too short for the layout, you have a few options for adjusting it to fit.

If the copy is too short, you can add leading, increase the type size, or decrease the line length (thereby changing the original layout).

If the copy is too long, you can reduce leading, decrease the type size, or increase the line length (thereby changing the original layout).

In addition to the above, you can ask the writer or editor to change the length of the manuscript copy by cutting or adding words.

LIST OF COMPLETE TYPESETTER'S INSTRUCTIONS:

Size	*in points*
Leading	*in points*
Line Length	*in picas*
Column Structure	*justified, fl l/rag r*
Type Family	*Cheltenham, Futura*
Weight	*lt, med, bold*
Posture	*roman, italic*
Capitalization	*CAPS, U/lc, lc*
Indentation	*in ems*
Let/Wrd Spacing	*from loose to touching*

MARKING COPY

Typesetting is expensive. Fewer errors and reset-tings mean cheaper jobs. The easiest way to reduce typesetting errors is to provide clear, complete instructions.

Shown above is a list of all the information a typesetter could need. It's a long list and you won't need to use all of it for every job, but each item should be considered.

11/12 x 28
JUSTIFIED
ITC GARAMOND LT
U/lc

To be, or not to be: that is the question: whether 'tis nobler in the mind to suffer the slings and arrows of outrageous fortune, or to take arms against a sea of troubles, and by opposing end them? To die: to sleep; no more; and by a sleep to say we end the heart-ache and the thousand natural shocks that flesh is heir to, 'tis a consummation devoutly to be wish'd.

□□] To die, to sleep; to sleep: perchance to dream: ay, there's the rub; for in that sleep of death what dreams may come when we have shuffled off this mortal coil, must give us pause: there's the respect that makes calamity of so long life; for who would bear the whips and scorns of time, the oppressor's wrong, the proud man's contumely, the pangs of despised love, the law's delay, the insolence of office and the spurns that patient merit of the unworthy takes, when he himself might his quietus make with a bare bodkin?

□ = 1 em

] = indent

□□] = 2 em indent

⊄ = 1 en (half the width of an em)

Translation of the shorthand used above:

11/12 × 28 justified ITC Garamond Lt U/lc □□]

type size in points	across or by	line length in picas	column structure	type family	weight	capitalization	paragraph indent

baseline/baseline in points

36 Most text type specs need only the information shown above.

The copy submitted to the typesetter should be typewritten, double-spaced, with as few corrections on the manuscript as possible. The instructions should be legibly written in the margin in red ink to be easily seen.

If you're unsure about how to spec a job, call your typesetter. You'll usually find the typesetter eager to help. Remember, it's cheaper to get help over the phone than to say "Set to fit," which makes the typesetter expend costly time figuring out the spec for you and making assumptions that may not produce what you want.

Sunshine and rain at once: her smile and tears.

A rough comp requires imagination to interpret.

Sunshine and rain at once: her smile and tears.

A tight comp looks more like final set type.

CREATING COMPS

Comprehensives, or **comps,** are renditions of a layout that provide a clear representation of exactly how the final printed result will appear, without the extra expense of setting type. They are used for working out your ideas. They are used for obtaining approval from your client, and they are used for providing clear instructions to the typesetter.

Comps can be prepared in a number of ways, from a "rough" to a "tight" comp. A **rough** is useful only to a highly visual person, because it leaves much to the imagination. A **tight comp** looks more like the final set type. The letterforms are carefully drawn, reflecting the size and weight of the typeface, and the spacing accurately represents the final typeset result.

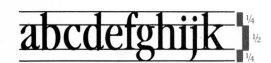

Baselines drawn for tracing.

Baselines, mean lines, ascenders, and descenders drawn for eyeballing.

abcdefghijk] ¼ ½ ¼

¼ ½ ¼

Proportional enlargement for correct ascender and descender depth.

38 | DISPLAY COMPING

If you have a sample of the display typeface in the size you want, tracing is the easiest and most accurate way to create a comp. If a correctly sized sample isn't available, you have to eyeball your type indication for whatever size type sample is at hand. For this reason, developing a solid ability to comp type by eye is extremely worthwhile.

Begin tracing a comp for display type by lightly indicating baselines in pencil. Keep in mind that the line spacing may have to be adjusted later. When eyeballing type, also lightly pencil in horizontal rules at the mean line and for the ascenders and descenders. Their depth can be determined by comparison to the x-height of the type sample you have.

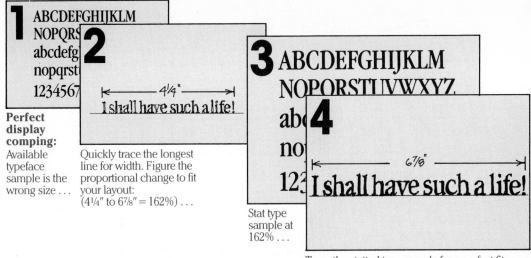

1 ABCDEFGHIJKLM NOPQRS abcdefg nopqrst 1234567

Perfect display comping:
Available typeface sample is the wrong size . . .

2 |←——— 4¼" ———→|
I shall have such a life!

Quickly trace the longest line for width. Figure the proportional change to fit your layout:
(4¼" to 6⅞" = 162%) . . .

3 ABCDEFGHIJKLM NOPQRSTUVWXYZ abc nop 123

Stat type sample at 162% . . .

4 |←——————— 6⅞" ———————→|
I shall have such a life!

Trace the statted type sample for a perfect fit.

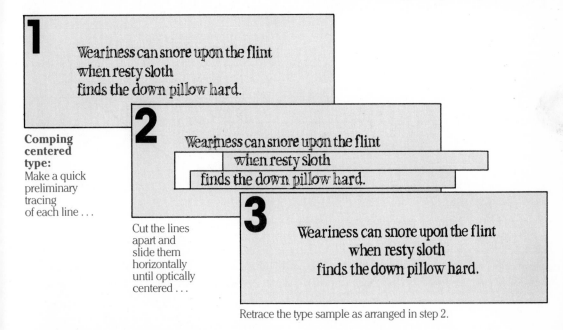

1 Weariness can snore upon the flint
when resty sloth
finds the down pillow hard.

Comping centered type:
Make a quick preliminary tracing of each line . . .

2 Weariness can snore upon the flint
when resty sloth
finds the down pillow hard.

Cut the lines apart and slide them horizontally until optically centered . . .

3 Weariness can snore upon the flint
when resty sloth
finds the down pillow hard.

Retrace the type sample as arranged in step 2.

For display type, your comp will establish how long the line or lines of copy will run. The most effective way to comp display type is to do a quick tracing of the longest line of your copy in the sample size closest to the size you want. Be attentive to letter and word spacing, because they partly determine how wide the line of type will be.

If the line runs longer or shorter than is desirable for your layout, make a photostat or photo-copy of the type sample at the appropriate size. Retrace the type from this sample. The result: a custom fit.

To comp a centered headline, make a quick preliminary tracing of each line, cut them apart, and slide horizontally until centered. Now retrace the type sample following your guide. .

Text comping should reflect each typeface's unique feel, texture, and color.

ULE "10" TYPE GAUGE

POINT SIZE

7	8	9	10	11	12			
2	2	2	2	2	1			
4	4	4	4	2	2			
6	6		4	4	3			
8	8	6	6		4			
10		8		6	5			
12	10		8	8	6			
14	12	10	10		7			
16	14	12		10	8			
		14	12		9			
					10			

Begin a text comp by indicating baseline increments in pencil. In this example, the baselines will be every 12 points. Make hash marks along the 12 scale, then simply extend the marks into horizontal rules across your full column width, using a T-square.

All three examples above are drawn with equal line spacing. The difference in apparent sizes is due to the loop heights that are drawn to correspond to the x-height of each face.

40 TEXT COMPING

The purpose of comping text type is to indicate as accurately as possible how the final type will look when set. It is not possible, however, to comp every character, as you can for display type. What you can achieve is an accurate "feel" of the typeface, its **texture** and **color** (the relative lightness or darkness of the type), an indication of how much space the type will take up in your design, and its relationship to the other elements in the layout.

Always start a comp by indicating baselines at appropriate increments. Comp a visually correct x-height (the single characteristic that determines apparent size). Typeset copy has word spaces, paragraph indents, and shorter last lines of paragraphs, so be sure to comp these too.

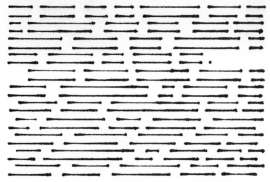

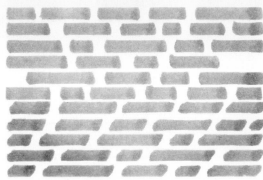

Parallel rules: Can't indicate italics; don't look too much like type.

Broad-nib marker rules: Give a good idea of color (many grays available), can create the effect of italics, but don't look much like set type.

Freehand looping: Looks more like set type but lacks the precision of type; good control over color and italics.

Mechanical looping: Done with a straightedge as a guide, gives an excellent feel of set type; good control over color and italics.

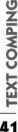

PILOT ultra fine point permanent SC-UF

This is an excellent pen for comping text copy; it is available in several colors and won't smear.

Shown above are four techniques for comping text type. Use the one that best combines speed and accuracy.

The parallel rule technique is satisfactory for very quick comping but does not convey italicized copy well. Broad-nib marker rules give a good idea of color (many grays are available) and can create italics but don't look much like real type. Freehand looping looks more like set type but lacks the precision inherent in set type. Mechanical looping–done with a straightedge as a guide– gives an excellent feel for set type.

Develop an arsenal of pens of different thicknesses for text comping. Using the right pen to match the weight of type is important. Trying to capture 12/13 Garamond Light and Bold with the same 00 pen nib doesn't work. You need the 00 for the light and 0 or maybe a 1 for the bold.

Original computer-generated comps for page 15 (left) and page 26 (right) of this book, shown half-size.

|

COMPUTER COMPS

Computer-generated comps are now a familiar sight to typesetters. The flexibility of computers is limitless, if you have the right software and enough fonts. Computers can get the job done and they are affordable. (This book was completely prepared on a computer; virtually every word and example was first created on a monitor screen.)

When using readily accessible, relatively affordable equipment (not the versatile and sophisticated machinery typesetters use), you'll find that the problem with computer-generated comps is in the printing. Color printers do not yet create lifelike images. A good hand-drawn marker comp is still better than a good computer image. Nevertheless, computers allow the designer to experiment with different sizes, weights, alignments, and leading.

1 Given 1281 manuscript characters and an area 17 picas wide by 5⅝″ deep, what is the **leading** that will best fill out the box, setting 11-point ITC Garamond Lt?

2 Given 1805 manuscript characters and an area 12 picas wide and setting 10/10, how **deep** will the area run in inches and picas?

3 What is the maximum number of **characters** of 11/12 a copywriter would have to write to fit a space 27 picas wide by 5″ deep?

4 Given 2,688 manuscript characters, how many **total lines** of 12/14 will there be in three equally deep 14 pica wide columns?

5 How many **set characters** will fit in a column 22 picas wide by 4″ deep, using 9/10?

6 How many **words** set 14/14 will fit in an area 21 picas wide by 6″ deep? (Average word length is five characters per word, including word space.)

7 Setting 176 manuscript words into a 15 pica wide by 3½″ box and using 10-point type, how many **lines** of set type will result and how many **points of leading** are needed?

Answers can be found on page 118.

EXERCISES

Copyfitting is a skill that improves with use. If you do it often, you can probably work your way through most unusual situations. If you copyfit only once in a while, some confidence-building exercises are useful.

The exercises above approach text copyfitting from several angles and therefore approximate working conditions. Use the copyfitting charts on page 31.

Part Two:
Type Samples

Figure 1

Figure 2

Thumbnails

SET ALL 9/10 X 12
JUST.
ITC AVANT GARDE
GOTHIC MED COND.

Figure 1

CAPS

NO INDENT

Figure 2 ADD 1 L#

NO INDENT

Enter Countess and Steward
Alas! and would you take the letter of her? Might you not know she
would do as she has done, by sending me a letter? Read it again.
I am Saint Jaques' pilgrim, thither gone: ambitious love hath so in me
offended, that barefoot plod I the cold ground upon, with sainted vow my
faults to have amended. Write, write, that from the bloody course of war
my dearest master, your dear son, may

ENTER COUNTESS AND STEWARD
Alas! and would you take the letter of her?
Might you not know she would do as she has
done, by sending me a letter? Read it again.

I am Saint Jaques' pilgrim, thither gone: am-
bitious love hath so in me offended, that
barefoot plod I the cold ground upon, with
sainted vow my faults to have amended.
Write, write, that from the bloody course of

When breaking up text with paragraphs, do not indent the first line
of text, especially following a head (Figure 1). When adding a line
space between paragraphs, do not also indent the first line of each
paragraph (Figure 2).

BREAKING UP TEXT

Text must be broken up into manageable
chunks for the reader so that the copy is easy to
follow. The familiar way of breaking up text is with
paragraphs.

Paragraphs are idea separators that begin a
new line. There are two conventional methods of
indicating paragraphs: by adding space before the
first word of a paragraph (called an **indent**) or by
adding space between paragraphs.

Do not indent the first line of the first para-
graph in running text, particularly if this line fol-
lows a head (Figure 1). When you mark the copy,
indicate that the first paragraph is flush left.

If you choose to insert space between para-
graphs, do not also indent the first line of each
new paragraph (Figure 2). Doing so is redundant.
When marking copy, tell the typesetter to add one
line space between paragraphs and do not indent.

Figure 1
Thumbnails

Figure 2

Figure 3

SET ALL 9/10
ITC AVANT GARDE
GOTHIC MED COND.

Figure 1
JUST X8

❑] What angel shall bless this unworthy husband? he cannot thrive, unless her prayers, whom heaven delights to hear and loves to grant, reprieve him from the wrath of greatest justice. Write, write, Rinaldo, to this unworthy husband of his wife; let every word weigh heavy of her worth that he does not weigh too light: my greatest grief, though little he do feel it, set

Figure 2
JUST X12

⊓] What angel shall bless this unworthy husband? he cannot thrive, unless her prayers, whom heaven delights to hear and loves to grant, reprieve him from the wrath of greatest justice. Write, write, Rinaldo, to this unworthy husband of his wife; let every word weigh heavy of her worth that he does not weigh too light: my greatest grief, though little he do feel it, set

Figure 3
FL/RR X12

⌐6] What angel shall bless this unworthy husband? he cannot thrive, unless her prayers, whom heaven delights to hear and loves to grant, reprieve him from the wrath of greatest justice. Write, write, Rinaldo, to this unworthy husband of his wife; let every word weigh heavy of her worth that he does not weigh too light: my greatest grief, though little he do feel it, set

What angel shall bless this unworthy husband? he cannot thrive, unless her prayers, whom heaven delights to hear and loves to grant, reprieve him from the wrath of greatest justice. Write, write, Rinaldo, to this unworthy

What angel shall bless this unworthy husband? he cannot thrive, unless her prayers, whom heaven delights to hear and loves to grant, reprieve him from the wrath of greatest justice. Write, write, Rinaldo, to this unworthy husband of his wife; let every word weigh heavy of her worth that he does not weigh too light: my greatest grief, though

What angel shall bless this unworthy husband? he cannot thrive, unless her prayers, whom heaven delights to hear and loves to grant, reprieve him from the wrath of greatest justice. Write, write, Rinaldo, to this unworthy husband of his wife; let every word weigh heavy of her worth that he does not weigh too light: my

A 1-em indent should be used for narrow column widths (Figure 1), but 2-em indents (Figure 2) are a good depth for most standard column widths. Extra-deep indents add drama (Figure 3).

Conventional indents are from 1 em to 3 ems deep. The indent you select largely depends on the width of the column and the type arrangement. For example, a l-em indent (Figure 1) may be sufficiently visible in copy set 8 picas wide but too shallow for copy set 30 picas wide. For standard column widths (13 to 24 picas) you will probably discover that a 2-em indent (Figure 2) is appropriate in most cases.

A deeper indent may be desirable when the copy is set ragged right, because a "hole" in unjustified copy is less apparent than a "hole" in squared-off copy. Figure 3 (6 ems deep) illustrates an extreme example. The indent is a full half column deep.

Figure 1
Figure 2
Figure 3

Thumbnails

SET ALL 9/10
ITC AVANT GARDE
GOTHIC MED COND.

Figure 1
JUST X 8½
HANG INDENTS
2 pi

[←— It is reported that he has taken their greatest commander; and that
with his own hand he slew the duke's brother. We have lost our labour;
they are gone a contrary way: hark!
[←— Come, let's return agains, and suffice ourselves with the report of it.
Well, Diana, take heed of this French earl: the honour of a maid is her
name; and no legacy is so rich as honesty.

Figure 2
JUST X 8
SET EVERY OTHER
¶ JUST X 10½
& ALIGN ON
RT. EDGE

[It is reported that he has taken their greatest commander; and that
with his own hand he slew the duke's brother. We have lost our labour;
they are gone a contrary way: hark!
[Come, let's return agains, and suffice ourselves with the report of it.
Well, Diana, take heed of this French earl: the honour of a maid is her
name; and no legacy is so rich as honesty.

Figure 3
ALTERNATE ¶'S:
FL/RR X 9
FR/RL X 9
& ALIGN FLUSH
EDGES ON 11 pi
COL. PER THUMBNAIL

[It is reported that he has taken their greatest commander; and that
with his own hand he slew the duke's brother. We have lost our labour;
they are gone a contrary way: hark!
[Come, let's return agains, and suffice ourselves with the report of it.
Well, Diana, take heed of this French earl: the honour of a maid is her
name; and no legacy is so rich as honesty.

It is reported that he has taken their
 greatest commander; and that
 with his own hand he slew the
 duke's brother. We have lost our
 labour; they are gone a con-
 trary way: hark!
Come, let's return agains, and suffice
 ourselves with the report of it.
 Well, Diana, take heed of this
 French earl: the honour of a
 maid is her name; and no leg-
 acy is so rich as honesty.

It is reported that he has taken
their greatest commander;
and that with his own hand he
slew the duke's brother. We
have lost our labour; they are
gone a contrary way: hark!
Come, let's return agains, and suffice
ourselves with the report of it. Well,
Diana, take heed of this French earl: the
honour of a maid is her name; and no
legacy is so rich as honesty.

It is reported that he has taken
their greatest commander; and
that with his own hand he slew
the duke's brother. We have lost
our labour; they are gone a con-
trary way: hark!
 Come, let's return agains, and
 suffice ourselves with the report
 of it. Well, Diana, take heed of
 this French earl: the honour of a
 maid is her name; and no leg-
 acy is so rich as honesty.

A hanging indent (Figure 1) is the opposite of a regular indent. The first line sticks out into the margin. Figure 2 shows alternating paragraphs set to different widths and aligned on the right edge. This is equivalent to indenting every line of every other paragraph. Figure 3 alternates column structure. Every other paragraph is set flush left.

47

Depending on the nature of the copy, paragraph-ing can be indicated in ways that are less conventional than the methods shown on the previous two pages. Figure 1 shows a **hanging indent,** which is the opposite of a regular indent. The first line is set wider than the rest of the paragraph. Indicate the amount of copy to hang by points, picas, or ems.

Figure 2 shows a technique of indenting every other paragraph. Here two different column widths are created, both set justified and aligned at the right edge. The paragraph indent is 2½ picas, the difference between the two column widths. Do not indent the first line of each new paragraph.

Separation of ideas can also be achieved by setting alternating paragraphs flush left, then flush right (Figure 3). Be sure that the *overall* column width is slightly wider than the column width for either the flush left or flush right paragraphs.

Figure 1
Thumbnails

Figure 2

SET ALL 9/10X14
JUST.
ITC AVANT GARDE
GOTHIC MED COND.

Figure 1
SET 1st TWO
WORDS OF EACH
¶ F.R. ON NEW
LINE: BREAK
AS SHOWN.

Is not this a strange fellow, my lord, that so confidently seems to undertake this business, which he knows is not to be done; damns himself to do and dares better be damned than do't?
Certain it is, that he will steal himself into a man's favour and for a week escape a great deal of discoveries. Find him, and have him.
Forsooth, do you think he will make no deed at all of this that so seriously he does address himself unto?

Figure 2
INDENT EACH
¶ TO POINT
BELOW PRECEDING
PERIOD - PER
THUMBNAIL

Is not this a strange fellow, my lord, that so confidently seems to undertake this business, which he knows is not to be done; damns himself to do and dares better be damned than do't?
Certain it is, that he will steal himself into a man's favour and for a week escape a great deal of discoveries. Find him, and have him.
Forsooth, do you think he will make no deed at all of this that so seriously he does address himself unto?

Is not this a strange fellow, my lord, that so confidently seems to undertake this business, which he knows is not to be done; damns himself to do and dares better be damned than do't?
Certain it is, that he will steal himself into a man's favour and for a week escape a great deal of discoveries. Find him, and have him.
Forsooth, do you think he will make no deed at all of this that so you think he will make no deed at all of this that so

Is not this a strange fellow, my lord, that so confidently seems to undertake this business, which he knows is not to be done; damns himself to do and dares better be damned than do't?
Certain it is, that he will steal himself into a man's favour and for a week escape a great deal of discoveries. Find him, and have him.
Forsooth, do you think he will make no deed at all of this that so seriously he does address himself unto?

In Figure 1 the first two words of each paragraph are set flush right. Drop paragraphs (Figure 2) begin each new paragraph directly below the previous period.

48 Two more ways of paragraphing are shown here. In Figure 1 each new paragraph begins with the first two words set flush right. Every paragraph will therefore have an opening line of a different length. The rest of each paragraph is set justified.

Figure 2 shows **drop paragraphs.** Each paragraph begins immediately below the period ending the preceding paragraph. This style of paragraphing is infrequently seen because it has a fault. You must be careful that the last line of a paragraph does not approach the full column width, because there will not be room for the first word of the next paragraph below it. In these instances the copy should be edited to shorten the last line.

Figure 1

Figure 2

Thumbnails

SET ALL 9/10 X 14
JUST.
ITC AVANT GARDE
GOTHIC MED COND.

Figure 1
NO ¶ INDENTS:
SET RUNNING
TEXT & INSERT
10pt DINGBAT G1

G1 - INSERT 4pt # BEFORE & AFTER

And how mightily some other times we drown our gain in tears! The great dignity that his valour hath here acquired for him shall at home be encountered with a shame as ample. • The web of our life is of a mingled yarn, good and ill together. Our virtues would be proud, if our faults whipped them not; and our crimes would despair, if they were not cherished by our virtues. How now! where's your master? • He met the duke in the street, sir, of whom he hath taken a solemn leave. His lordship will next morning for France. The duke hath offered him letters of commendation to

Figure 2
NO ¶ INDENTS:
SET RUNNING
TEXT & ALTERNATE
9/10 MED COND.
WITH
9/10 BOLD COND.
FOR EACH ¶ .

And how mightily some other times we drown our gain in tears! The great dignity that his valour hath here acquired for him shall at home be encountered with a shame as ample.
The web of our life is of a mingled yarn, good and ill together. Our virtues would be proud, if our faults whipped them not; and our crimes would despair, if they were not cherished by our virtues. How now! where's your master?
He met the duke in the street, sir, of whom he hath taken a solemn leave. His lordship will next morning for France. The duke hath offered him letters of commendation to the king. They shall be no more than need

And how mightily some other times we drown our gain in tears! The great dignity that his valour hath here acquired for him shall at home be encountered with a shame as ample. ★ The web of our life is of a mingled yarn, good and ill together. Our virtues would be proud, if our faults whipped them not; and our crimes would despair, if they were not cherished by our virtues. How now! where's your master? ★ He met the duke in the street, sir, of whom he hath taken a solemn leave. His lordship will next morning for France. The duke hath offered him let-

And how mightily some other times we drown our gain in tears! The great dignity that his valour hath here acquired for him shall at home be encountered with a shame as ample. **The web of our life is of a mingled yarn, good and ill together. Our virtues would be proud, if our faults whipped them not; and our crimes would despair, if they were not cherished by our virtues. How now! where's your master?** He met the duke in the street, sir, of whom he hath taken a solemn leave. His lordship will next morning for France. The duke hath offered him let-

Inserting dingbats instead of breaking lines for the beginning of each new paragraph saves space (Figure 1). Spec the space before and after each dingbat. Alternating two weights of type (Figure 2) in running text can also define paragraph breaks.

49

Paragraphs separate ideas by starting on a new line, but you can separate or emphasize ideas without beginning a new line. The ways of doing this are limitless as long as sufficient contrast exists to signal the reader.

If you need to save a few lines of space, run all paragraphs together and use a dingbat to indicate the start of a new idea (Figure 1). Indicate the space before and after each dingbat in points. Specify dingbats that will fit within your leading requirements; using the same size as the sur-

rounding type will always work. Dingbats are designated by a letter and number code. G1 happens to be the designation for the star dingbat shown here, but these codes vary from typesetter to typesetter.

Creating emphasis in continuous text can be achieved by alternating roman type with italic or bold type, or with type printed in a second color (Figure 2).

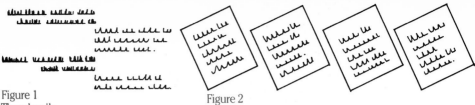

Figure 1
Thumbnails

Figure 2

Figure 1
10/10 X 13 OPTIMA
F.L. ALTERNATING
WITH BOLD F.R.
ON CENTRAL AXIS
PER THUMBNAIL

Look, where they come: take but good note, and you shall see him the triple pillar of the world transform'd into a strumpet's fool.
If it be love indeed, tell me how much.
If there's beggary in the love that can be reckon'd.
I'll set a bourn how far to be beloved.
Then must thou needs find out new heaven, new earth.

Figure 2
9/10 X 5 FL/RR
OPTIMA - SET IN
5 ll GROUPS INSIDE
6 X 7 pi ½-pt BOXES
PER THUMBNAIL

Let Rome in Tiber melt, and the wide arch of the ranged empire fall! Here is my space. Kingdoms are clay: our dungy earth alike feeds beast as man. The nobleness of life is to do thus; when such a mutual pair and such a twain can do't, in which to bind, on pain of punishment.

Look, where they come: take but good note, and you shall see him the triple pillar of the world tranform'd into a strumpet's fool.

If it be love indeed, tell me how much.

If there's beggary in the love that can be reckon'd.

I'll set a bourn how far to be beloved.

Then must thou needs find out new heaven, new earth.

Let Rome in Tiber melt, and the wide arch of the ranged empire fall!

Here is my space. King-doms are clay: our dungy earth alike feeds beast

as man. The nobleness of life is to do thus; when such a mutual pair and

such a twain can do't, in which to bind, on pain of punishment.

Copy can be broken for sense (Figure 1) or arbitrarily broken into sections, which are then given special graphic treatment (Figure 2).

50

Copy can be grouped into parts in logically determined sections (Figure 1) or in clusters of type that are visually appealing (Figure 2).

Figure 1 shows a visual representation of a conversation. The breakup of copy follows a logical pattern (also called **breaking for sense**). Select contrasting typefaces for the two "voices" and spec it to be set in alternating paragraphs of flush left and flush right copy off a central axis. Send along a thumbnail.

Figure 2 illustrates copy broken into short, boxed sections tipped on the diagonal. The copy is set horizontally (diagonal setting cannot be accomplished with current technology). Specs call for flush left setting in groups of five lines. Each five-line cluster is then enclosed within a ½-point box rule. The type is tipped sideways on the board.

Figure 1
Thumbnails

Figure 2

Figure 1
9/10 X 10 JUST.
OPTIMA : NO ¶ INDENTS
SET 1ST TWO WORDS
OF EACH ¶ AS
BOLD LEAD-IN.

⌐ <u>And the</u> business you have broached here cannot be without you.
Especially that of Cleopatra's, which wholly depends on your abode.⌐
⌐ <u>No more</u> light answers: let our officers have notice what we purpose.
I shall break the cause of our expedience to the queen, and get her
leave to part. For not alone the death of Fulvia, with more urgent

Figure 2
9/10 X 10 FL/RR
OPTIMA: NO ¶ INDENTS
SET 1ST SENTENCE
OF EACH ¶ AS
BOLD LEAD-IN.

⌐ <u>And the business you have broached here cannot be without you.</u>
Especially that of Cleopatra's, which wholly depends on your abode.⌐
⌐ <u>No more light answers: let our officers have notice what we purpose.</u>
I shall break the cause of our expedience to the queen, and get her
leave to part. For not alone the death of Fulvia, with more urgent

And the business you have broached here cannot be without you. Especially that of Cleopatra's, which wholly depends on your abode.
No more light answers: let our officers have notice what we purpose. I shall break the cause of our expedience to the queen, and get her leave to part. For not alone the

And the business you have broached here cannot be without you. Especially that of Cleopatra's, which wholly depends on your abode.
No more light answers: let our officers have notice what we purpose. I shall break the cause of our expedience to the queen, and get her leave to part. For not

Two types of lead-ins: Figure 1 is an example of a short lead-in, only two words per paragraph. Figure 2 shows a full sentence lead-in.

Text can be broken up by using **lead-ins.** Lead-ins are the first few words of a paragraph set in italics, boldface, or all caps, suggesting a **subhead,** or secondary headline. Here are two examples of text in which lead-ins introduce a new thought.

In Figure 1 the first two words of each paragraph are set in boldface. Since the lead-ins signal the beginning of a new thought, indents are redundant.

In Figure 2 an entire sentence functions as a lead-in. The lead-in is specified in the same face and size as the text, but is bold. The type change creates a smooth transition from head to text.

Thumbnail

ALL TEXT IS
11/11 X 23 JUST.
OPTIMA

Nay, nay, Octavia, not only that, that were excusable, that, and thousands
more of semblable import, but he hath waged new wars 'gainst Pompey.
Made his will, and read it to public ear: spoke scantily of me when
perforce he could not but pay me terms of honour, cold and sickly
he vented them; most narrow measure lent me. When the best hint was
given him, he not took't, or did it from his teeth:

INSERT 1 l #

10/10 X 19 JUST.
CENTER COL. &
DELETE QUOTE
MARKS

INSERT 1 l #

TEXT

O my good lord, believe not all; or, if you must believe, stomach
not all. A more unhappy lady, if this division chance, ne'er stood
between, praying for both parts. The good gods will mock me presently,
when I shall pray, 'O, bless my lord and husband!' Undo that prayer,
by crying out as loud, 'O, bless my brother!'

Gentle Octavia, let your best love draw to that point, which seeks
best to preserve it. If I lose mine honour, I lose myself: better
I were not yours than yours so branchless. But, as you requested,
yourself shall go between's. The mean time, lady, I'll raise the

terms of honour, cold and sickly he vented them; most narrow
measure lent me. When the best hint was given him, he not
took't, or did it from his teeth.

O my good lord, believe not all; or, if you must believe,
stomach not all. A more unhappy lady, if this division
chance, ne'er stood between, praying for both parts. The
good gods will mock me presently, when I shall pray, 'O,
bless my lord and husband!' Undo that prayer, by crying
out as loud, 'O, bless my brother!'

Gentle Octavia, let your best love draw to that point, which seeks
best to preserve it. If I lose mine honour, I lose myself: better I were
not yours than yours so branchless. But, as you requested, your-

An extract is a lengthy excerpt or quote separated from the main text. Set an
extract across a narrower column width and in a smaller type size than the
surrounding text.

BREAKING UP TEXT

52 Scholarly articles often include lengthy quotations
or excerpted material in the running text. These
are called **extracts.** It is customary to set extracts
in a smaller point size, with less leading and
across a narrower column width than the main
text. Usually one line space is inserted above and
below an extract.

Because the type in an extract is set to con-
trast with the surrounding text, it does not require
the use of quotation marks. Nor is it necessary to
indent either the extract or the opening line of the
following text.

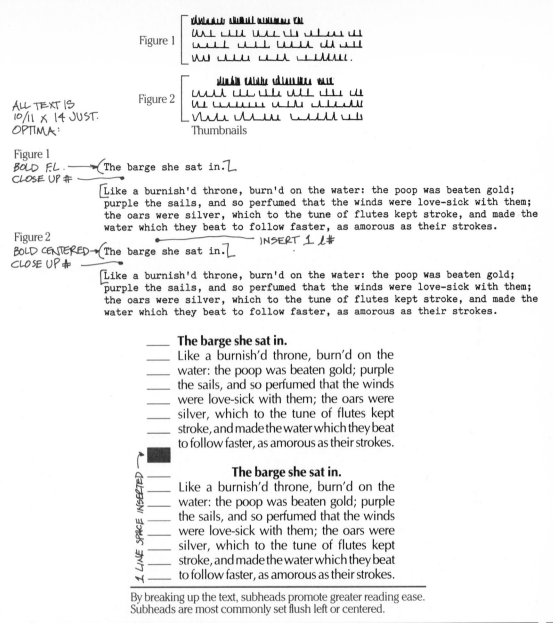

By breaking up the text, subheads promote greater reading ease.
Subheads are most commonly set flush left or centered.

Subheads offer a method of breaking up the text, making copy more inviting to the reader.

Long, unbroken passages of 11-point type can look threatening because the copy looks like *work* to read, especially if the reader doesn't have a particularly keen interest in the subject. Long copy appears more accessible if it is broken into smaller pieces with subheads.

The two most common subheads appear here. Figure 1 shows a flush left head; Figure 2

shows the same head centered. These two subheads are set with the same leading as the text so that the baselines match. This treatment ensures that baselines in all columns *across* the page will align.

A line space inserted above the subhead (Figure 2) produces greater visibility.

Figure 1
Thumbnails

Figure 2

ALL TEXT IS
10/11 × 14 OPTIMA.

Figure 1

FL/RR →
```
thy discontented sword, and carry back to Sicily much tall youth that else
must perish here.
```
←— INSERT 1 l #

BOLD, FL/RR →
BREAK AS SHOWN
```
To you all three, the senators alone of this great world, chief factors
for the gods.
```

FL/RR →
```
I do not know wherefore my father should revengers want, having a son
and friends.  Since Julius Caesar, who at Philippi the good Brutus ghosted,
there saw you laboring for him.  What was't that moved pale Cassius to
```

Figure 2

JUST. →
```
thy discontented sword, and carry back to Sicily much tall youth that else
must perish here.
```
←— INSERT 1 l #

BOLD, CENTER →
BREAK AS SHOWN
```
To you all three, the senators alone of this great world, chief factors
for the gods.
```

JUST. →
```
I do not know wherefore my father should revengers want, having a son
and friends.  Since Julius Caesar, who at Philippi the good Brutus ghosted,
there saw you laboring for him.  What was't that moved pale Cassius to
```

sword, and carry back to Sicily much tall
youth that else must perish here.

**To you all three, the senators
alone of this great world,
chief factors for the gods.**
I do not know wherefore my father should
revengers want, having a son and friends.
Since Julius Caesar, who at Philippi the
good Brutus ghosted, there saw you
laboring for him. What was't that moved

carry back to Sicily much tall youth that
else must perish here.

**To you all three, the senators
alone of this great world,
chief factors for the gods.**
I do not know wherefore my father should
revengers want, having a son and friends.
Since Julius Caesar, who at Philippi the
good Brutus ghosted, there saw you labor-
ing for him. What was't that moved pale

Multiple-line subheads can be set flush left or centered. Leaving a line space above a subhead makes the head appear to "belong" to the copy below it. Spec this as "insert one line space."

54

For subheads that are long enough to require **turnovers** (type continued onto the next line), there are two common arrangements: flush left and centered.

A flush left head works well with text that is flush left (Figure 1), while a centered head works well with justified text (Figure 2).

When specifying heads that turn over, retain the same leading as in the text so that all columns share the same base alignment.

The line breaks in both examples are dictated by what reads most logically. (Note the indications for line breaks in the manuscript.)

Do not indent the first line of text following a subhead. The change in type weight signals that a new idea is beginning.

Figure 1
Thumbnails

Figure 2

Figure 1
10/11 × 14 JUST.
OPTIMA

were my conquerer; and that my sword, made weak by my affection, would obey it on all cause.

CLOSE UP #

④] Fall not a tear, ⚡ ← BAD
I say, one of them rates all that is won and lost: give me a kiss; even this repays me. We sent our schoolmaster; is he come back? Love, I am full of lead. Some wine, within there, and our viands! Fortune knows we

Figure 2
10/11 × 11½ JUST.

were my conquerer; and that my sword, made weak by my affection, would obey it on all cause.

INSERT 1 ℓ #

HANG BOLD ──→⌐ Fall not a tear ℓ
SUBHD 2½pi ⌐ I say, one of them rates all that is won and lost: give me a kiss; even this repays me. We sent our schoolmaster; is he come back? Love, I am full of lead. Some wine, within there, and our viands! Fortune knows we scorn her most when most she offers blows. Let him appear that's come

conquerer; and that my sword, made weak by my affection, would obey it on all cause.

Fall not a tear

I say, one of them rates all that is won and lost: give me a kiss; even this repays me. We sent our schoolmaster; is he come back? Love, I am full of lead. Some wine, within there, and our viands! Fortune knows we scorn her most when most she

made weak by my affection, would obey it on all cause.

Fall not a tear

I say, one of them rates all that is won and lost: give me a kiss; even this repays me. We sent our school-master; is he come back? Love, I am full of lead. Some wine, within

A deep indent of 4 ems for both the subhead and the first line of text makes it unnecessary to insert a line space above the head (Figure 1). A hanging subhead (Figure 2) is specced like a hanging indent and indicates the amount of overhang in points, picas, or ems.

Here are two other variations of subheads. Figure 1 shows a deep indent shared by the subhead and the first line of text. It is not necessary to add a line space above the head, because the two deep indents create sufficient separation and visibility. An indent of this type should be at least 4 ems deep to have adequate impact.

Figure 2 is a hanging subhead, specced in the same way as a hanging indent (page 47). Indicate the overhang space in points, picas, or ems, and add one line space above the head.

Figure 1
Thumbnails

Figure 2

Figure 1

TEXT:
10/11 x 11 JUST. → [so it should be, that none but Antony should conquer Antony.
OPTIMA
 — INSERT 1 ℓ #
16/14 BLD-CNTR → [But [woe 'tis] so!]
ℓ/ℓ PER THMBNAIL
 [I am dying, Egypt. Dying, only I here importune death awhile, until of
 TEXT → |many thousand kisses the poor last I lay upon thy lips. I dare not, dear,
Figure 2 [dear my lord, pardon, I dare not, lest I be taken. Not the imperious show

TEXT:
10/11 x 12 JUST. → [so it should be, that none but Antony should conquer Antony.
OPTIMA
 — INSERT 1 ℓ #
16/14 BLD -FR. → [But [woe 'tis] so!]
PER THUMBNAIL
 [I am dying, Egypt. Dying, only I here importune death awhile, until of
TEXT & INDENT → |many thousand kisses the poor last I lay upon thy lips. I dare not, dear,
1st 4 ℓℓ x 4pi |dear my lord, pardon, I dare not, lest I be taken. Not the imperious show
PER THUMBNAIL |of the full-fortuned Caesar ever shall be brooch'd with me. If knife,
 [drugs, serpents have edge, sting, or operation, I am safe. Your wife

so it should be, that none but
Antony should conquer Antony.

**But
woe 'tis
so!**

I am dying, Egypt. Dying, only I
here importune death awhile, un-
til of many thousand kisses the
poor last I lay upon thy lips. I dare
not, dear, dear my lord, pardon, I
dare not, lest I be taken. Not the

so it should be, that none but Antony
should conquer Antony.

**But
woe 'tis
so!** I am dying, Egypt.
Dying, only I here im-
portune death awhile,
until of many thousand
kisses the poor last I lay upon thy lips.
I dare not, dear, dear my lord, par-
don, I dare not, lest I be taken. Not the
imperious show of the full-fortuned
Caesar ever shall be brooch'd with
me. If knife, drugs, serpents have

Subheads can be quite decorative. These examples look best when one line space is added above each heading.

56 Though functional, subheads may be used as decorative elements on the page. Figure 1 shows a centered subhead set so that its midpoint aligns above the left edge of the copy. Because the line spacing increments between subhead and text are different, this subhead will alter the base alignments across two or more columns. It is advisable to use this arrangement only with a single-column format. Insert a line space above the subhead, and don't indent the first line of text.

A subhead can also be set into the text itself (Figure 2). The visual separation will be clear if there is sufficient contrast between the head and the text. Be sure the type aligns neatly. Here four lines of text run 44 points deep (4 × 11 points), so the three-line subhead must run no deeper than 44 points. A type sample book was checked to determine which size display type would fit into this space.

Figure 1
Thumbnails

Figure 2

Figure 1

10/11 x 14 JUST.
OPTIMA

2 x ½pt RULES
x 14pi
8/9 CAPS, 3ll
CENTERED PER
THUMBNAIL

INSERT 1 l #

2pt #

taking dissolve, thick cloud, and rain; that I may say the gods themselves do weep!

I HAVE IMMORTAL LONGINGS IN ME: NO MORE THE JUICE OF EGYPT'S GRAPE SHALL MOIST THIS LIP

This proves me base: if she first meet the curled Antony, he'll make demand of her, and spend that kiss which is my heaven to have. Come, thy mortal wretch, with thy sharp teeth this knot intrinsicate of life at once

Figure 2

10/11 x 14 JUST.
OPTIMA

14 pt CAPS
CENTERED BTWN
30pt CAPS PER
THUMBNAIL

INSERT 15pt #

30pt CAPS 4pt #

1pt RULES x 14pi

taking dissolve, thick cloud, and rain; that I may say the gods themselves do weep!

GIVE ME MY ROBE

This proves me base: if she first meet the curled Antony, he'll make demand of her, and spend that kiss which is my heaven to have. Come, thy mortal wretch, with thy sharp teeth this knot intrinsicate of life at once

dissolve, thick cloud, and rain; that I may say the gods themselves do weep!

I HAVE IMMORTAL LONGINGS IN ME:
NO MORE THE JUICE OF EGYPT'S GRAPE
SHALL MOIST THIS LIP

This proves me base: if she first meet the curled Antony, he'll make demand of her, and spend that kiss which is my heaven to have. Come, thy mortal wretch, with thy

dissolve, thick cloud, and rain; that I may say the gods themselves do weep!

GIVE ME MY ROBE

This proves me base: if she first meet the curled Antony, he'll make demand of her, and spend that kiss which is my heaven to have. Come, thy mortal wretch, with thy

Subheads can be set with rules for added distinction. Properly specced, subheads like these come back from the typesetter in one piece. Include instructions for all type and rules, as well as the spacing between elements–and be sure to send a sketch.

Subheads can also be combined with horizontal rules to create an effective visual separation. The typesetter can easily set rules in thicknesses from hairline (¼ point) to 72 points. (For more on rules, see page 102.)

Figure 1 shows two ½ point rules placed above and below a subhead that is set 2 points smaller than the text. When the subhead is set in caps and placed between rules, a distinct separation is achieved between head and text.

Figure 2 shows a more complicated combination of type sizes and horizontal rules. When specifying a design as complex as this, always provide a very clear comp for the typesetter. Be certain to mark the size and measure of the rules, the spacing above and below the rules, as well as the size and face of the type.

Figure 1
36 pt ITC FENICE BLD
U/lc TNT

We burn daylight.

Figure 2
36pt ITC FENICE BLD
U/lc 6pt OPTICAL SPACE
BETWEEN CHARACTERS &
24 pt # BETWEEN WORDS

We burn daylight.

We burn daylight.
Figure 1

We burn daylight.
Figure 2

Figure 1 is set tight-not-touching (TNT), while Figure 2 is set quite a bit more loosely. Letterspacing can be specified in steps from touching to open (see page 20).

58 DISPLAY TYPE

Display type is meant to catch the reader's attention and to create a visual impression for the page. Display type is generally said to be 18 points and larger, but smaller type can be considered display if it is highly visible. Even a 12-point head can be display if there is enough space around it to attract the reader's attention.

At the other extreme, the 18-point cutoff between text and display type is too low for very large applications. The text type for billboards is typically 6 to 8 inches (432 to 576 points!), and the display type can be from 10 inches to 14 feet, the height of the billboard itself.

When specifying display type, consider the letterspacing. You may prefer a tight fit between letters, or you may choose loose letterspacing. This is a personal design decision.

WHAT! WOULDST THOU
HAVE A SERPENT STING
THEE TWICE?

What! wouldst thou
have a serpent sting
thee twice?

Figure 1
Thumbnails

Figure 2

Figure 1
ITC FENICE BOLD CAPS
3 ℓℓ CENTERED

→ 20/18 · 16/14 · 20/18
WHAT! WOULDST THOU⌐HAVE A SERPENT STING⌐THEE TWICE?

48pt INITIAL CAP, KERNED

Figure 2
20/20 F.R.
ITC FENICE BOLD U/lc
ℓ/ℓ

→ Ⓦhat! wouldst thou⌐have a serpent sting⌐thee twice?

WHAT! WOULDST THOU
HAVE A SERPENT STING
THEE TWICE?

What! wouldst thou
have a serpent sting
thee twice?

Line spacing is important in display type. It is used to create visually equivalent spaces between lines of type. An all-caps setting permits very tight spacing because there are no descenders (Figure 1). Lowercase type requires adjustments between lines that have ascenders and descenders (Figure 2).

When specifying display type, consider the line spacing. Figure 1 shows two sizes of display type specified with consistent line spacing. The first and last lines are set in 20 point, and the middle line is set in 16 point. There are 2 points of space separating lines of type. The minus-leading figures (20/18 and 16/14) were determined after completing a tight tissue tracing from a type sample book.

If the display type is to be set in lowercase, ascenders or descenders will influence the line spacing. Many ascenders and descenders will cause lines of type to appear closer together. In Figure 2 there are no descenders hanging in the space between the first and second lines. By comparison, the space between the second and third lines has many more interruptions. The leading of the first space was tightened slightly on the board to compensate, and so the line spacing *appears* to be consistent with the line space below.

Figure 1
Thumbnails

Figure 2

Figure 1
24/22 FUTURA
EX-BLK COND.
FR/RL l/l U/lc
HANG PUNCTUATION

This morning, ⌐like the⌐spirit of a⌐youth that⌐means to ⌐be of note,⌐ begins⌐betimes.⌐

Figure 2
14/19 FUTURA
EX-BLK COND.
ALL CAPS
CENTER l/l
AS BROKEN

Double, double toil and trouble; ⌐fire burn and cauldron bubble.⌐Fillet of fenny snake, ⌐in the cauldron boil and bake; ⌐eye of newt and toe of frog,⌐ wool of bat and tongue of dog, ⌐adder's fork and blind-worm's sting,⌐ lizard's leg and howlet's wing, ⌐for a charm of powerful trouble,⌐like a hell-broth boil and bubble.⌐

This morning, like the spirit of a youth that means to be of note, begins betimes.

DOUBLE, DOUBLE TOIL AND TROUBLE; FIRE BURN, AND CAULDRON BUBBLE. FILLET OF FENNY SNAKE, IN THE CAULDRON BOIL AND BAKE; EYE OF NEWT AND TOE OF FROG, WOOL OF BAT AND TONGUE OF DOG, ADDER'S FORK AND BLIND-WORM'S STING, LIZARD'S LEG AND HOWLET'S WING, FOR A CHARM OF POWERFUL TROUBLE, LIKE A HELL-BROTH BOIL AND BUBBLE.

To keep the flush edge of copy visually squared off, have punctuation hang in the margin (Figure 1). Breaking display headlines for sense helps communicate the message more clearly, as does printing the key phrase in a screen tint or second color (Figure 2).

60 Instruct the typesetter to hang punctuation (periods, commas, hyphens, quote marks, colons, semi-colons, and apostrophes) if you are setting flush lines of display type. **Hung punctuation** is set in the margin so that flush edges appear even (Figure 1). Punctuation that hangs in the margin does not destroy the sense of a squared-off edge, whereas punctuation that falls within the measure at the beginning or end of a line tends to look like a shallow indent.

The meaning of a headline can be emphasized by running the key phrase in a screen tint or in a second color (Figure 2). The headline should be set normally, because this modification is made by the printer, not by the typesetter.

The words in a headline frequently dictate how display type is arranged. Breaking for sense clearly communicates the meaning of the headline. Line breaks should be indicated on the manuscript with Z-shaped lines.

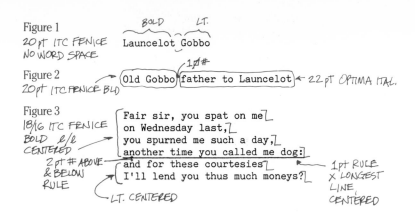

Figure 1
20 pt ITC FENICE
NO WORD SPACE

BOLD LT.

Launcelot Gobbo

Figure 2
20 pt ITC FENICE BLD

1Ø#

Old Gobbo father to Launcelot ← 22 pT OPTIMA ITAL.

Figure 3
18/16 ITC FENICE
BOLD ℓ/ℓ
CENTERED

Fair sir, you spat on me
on Wednesday last,
you spurned me such a day,
another time you called me dog:

2 pt # ABOVE
& BELOW
RULE

and for these courtesies
I'll lend you thus much moneys?

1 pt RULE
X LONGEST
LINE,
CENTERED

LT. CENTERED

LauncelotGobbo

Old Gobbo *father to Launcelot*

Fair sir, you spat on me
on Wednesday last,
you spurned me such a day,
another time you called me dog:

and for these courtesies
I'll lend you thus much moneys?

Emphasizing part of a headline can be achieved by using contrasting typefaces. You can change the weight alone (Figure 1) or change everything except the x-height (Figure 2). A 1-point rule emphasizes the contrasting type weights in Figure 3.

Combine display typefaces with care. Mismatched x-heights can make the type much more difficult to read. You can afford to take a few risks here, however, because display type is meant to be engaging, even if its treatment is sometimes at the expense of readability.

Figures 1 and 2 show simple typeface combinations on a single line. In Figure 1 only the weight of the face has been changed. In Figure 2 a change has been made in typeface, weight, stress, and style of letterforms. For the single-line head-lines, no line length or leading designation is necessary. Only typeface and point size are specified.

Figure 3 shows a combination of typefaces stacked with a horizontal rule. Notice the spec for the rule; " × longest line, centered." The typesetter will match the length of this rule to the longest line of set copy.

Comp: Text fits around the illustration.

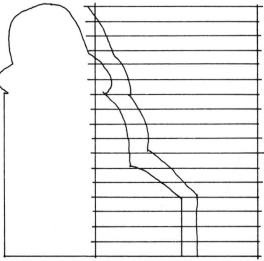

Step 1: Draw a tracing of the shape. Leave 1 pica space between the illustration and text.

Step 2: Draw horizontal baselines at correctly spaced increments. Draw a vertical rule at the edge of the longest line of text.

62 RUNAROUNDS

Type can be set to fit around other type, photographs, or illustrations. A type arrangement that wraps around these elements is called a **runaround.** There are various kinds of runarounds, but in all cases the type is specced using the same method.

First determine how long each line is in picas. To accomplish this, make a tracing of the shape, leaving a consistent space of 1 pica between the edge of the illustration (or display type) and the text (Step 1). This space is usually sufficient for separating any two elements.

Next, draw in the baselines at the correct line spacing increments to match the typeset copy. Draw in a vertical rule at the edge of the longest line of text to use as a point of reference when figuring indentations (Step 2).

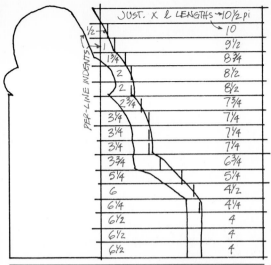

JUST. X ℓ LENGTHS →10½ pi	
½	10
1	9½
1¾	8¾
2	8½
2	8½
2¾	7¾
3¼	7¼
3¼	7¼
3¼	7¼
3¾	6¾
5¼	5¼
6	4½
6¼	4¼
6½	4
6½	4
6½	4

(left column labeled vertically: PER-LINE INDENTS)

10/11 ITC GARAMOND LT.
JUST. & INDENT X ℓ LENGTHS SHOWN ON SKETCH.

Some say thy fault is youth, some wantonness; some say thy grace is youth and gentle sport. Both grace and faults are loved of more and less; thou makest faults graces that to thee resort. As on the finger of a throned queen the basest jewel will be well esteem'd, so are those errors that in thee are seen to be truthful translated

Step 3: Measure each line from the vertical rule. The small vertical rules indicate the beginnings of each line of set type.

Step 4: Mark the copy with instructions based on the calculations in Step 3.

Some say thy fault is youth, some wantonness; some say thy grace is youth and gentle sport. Both grace and faults are loved of more and less; thou makest faults graces that to thee resort. As on the finger of a throned queen the basest jewel will be well esteem'd, so are those errors that in thee are seen to be truthful

Final typeset result: Check that line lengths, hyphenation, and word spacing are acceptable.

Next, draw short, vertical rules where each line begins, following the contour of the shape around which you are running text. Measure each line for text length (Step 3).

Submit both the manuscript copy (Step 4) and the sketch you've drawn in Step 3 to the typesetter. The typeset result may be correct after the first pass through typesetting, but it's likely that a second setting may be needed to correct hyphenation and word spacing.

In general, a runaround–such as the one illustrated here–is made more dramatic if the copy runs around at one edge and is flush at the opposite edge.

Thumbnail

JUST. x 16 pi
16
9
9
9
9
9
9
9
16
16
16
16 to end ┐

1 pt RULE x 6½ pi

←——— 7pi INDENT ———→

1 pt RULE x 6½ pi

11/12 x 16 JUST.
ITC GARA. LT.
INDENT LINES 3-9
7pi ON RT. SIDE
PER SKETCH.
HYPHENS O.K.

My glass shall not persuade me I am old, so long as youth and thou are of one date; but when in thee time's furrows to behold, then look I death my days should expiate. For all that beauty that doth cover thee is but the seemly raiment of my heart, which in thy breast doth live, as thine in me: how can I then be elder than thou art? O, therefore, love, be of thyself so wary as I, not for myself, but for thee will; bearing thy heart, which

My glass shall not persuade me I am old, so long as youth and thou are of one date; but when in thee time's furrows to behold, then look I death my days should expiate. For all that beauty that doth cover thee is but the seemly raiment of my heart, which in thy breast doth live, as thine in me: how can I then be elder than thou art? O, therefore, love, be of thyself so wary

A simple cut-in has shortened lines that are all equal in length (9 picas).

When specifying runarounds, always give the typesetter an accurate comp and mark the pica measure for each line, using the method described on the previous spread.

In the example above, type runs around a simple cut-in; an illustration of glasses has been separated by rules. Specifying the type is relatively simple here, because each line of the runaround is consistent in length. The full column width measures 16 picas. The illustration measures 6 picas, and the space between the text and illustration is 1 pica. Therefore, 16 minus 7 leaves a 9-pica width for the runaround.

As an
unperfect
actor

Thumbnail

As an
unperfect
actor

½ pi #

JUST. X9 pi
9
9
9
9
16
16
16
16 to end

27/20 ITC GARA BLD.
SET IN 3ll F.R. (As an⌐unperfect⌐actor⌐

11/12 X 16 JUST. → ⌐On the stage who with his fear is put besides his part, or some fierce
ITC GARA. LT. thing replete with too much rage, whose strength's abundance weakens his
INDENT 1st 5ll own heart, so I, for fear of trust, forget to say the perfect ceremony of
X 7pi PERSKETCH. love's rite, and in my own love's strength seem to decay, o'ercharged with

As an unperfect actor

As an
unperfect
actor
on the stage who with
his fear is put besides
his part, or some fierce
thing replete with too
much rage, whose
strength's abundance weakens his own
heart, so I, for fear of trust, forget to say the
perfect ceremony of love's rite, and in my
own love's strength seem to decay, o'er-

The text type is indented 7 picas to wrap around the display
type. A ½-pica space separates the two elements.

Here is another simple cut-in. Display type is set
flush right and clearly leads the reader into the text
type. The comp shows that the third line of display
type and the fifth line of text type align at their
baselines. The first five lines of text are indented
6 picas to allow for the display, and ½-pica space
is used to separate the display from the text copy.

Five lines of 11/12 type run 60 points deep
(5 × 12 points). The depth of three lines of dis-
play type must therefore also fit into 60 points.
Three lines divide equally into 20 points each,
baseline to baseline. The type was specified 24/20
(minus leading) to fit the space precisely.

LORD OF MY LOVE,
TO WHOM IN
VASSALAGE

Thumbnail

2 pt RULE x 16pi

LORD OF MY LOVE, MIN. 1/2 pi #

TO WHOM IN

VASSALAGE

18 pt #

JUST. x 7pi

7	
7	
7	
16	
16	
16	
16	
16 to end	

20/24 ITC GARA BLD.
ITAL. COND.
ALL CAPS, F.L.
PER LAYOUT

12/12 ITC GARA. LT.
1st 4ll JUST x 7pi
REMAINDER
JUST x 16 pi PER
SKETCH.

2 pt RULE x 16pi

LORD OF MY LOVE, TO WHOM IN VASSALAGE

thy merit hath my duty strongly knit, to thee I send this written
embassage, to witness duty, not to show my wit: duty so great, which wit
so poor as mine may make seem bare, in wanting words to show it, but that
I hope some good conceit of thine in thy soul's thought, all naked, will

LORD OF MY LOVE, TO WHOM IN VASSALAGE

thy merit hath my duty strongly knit, to thee I send this written embassage, to witness duty, not to show my wit: duty so great, which wit so poor as mine may make seem bare, in wanting words to show it, but that I hope some good conceit of thine in thy soul's

A simple cut-in is shown with headline and overscore. The headline is set flush left, ragged right. The text is set justified across two line lengths.

66

In this example, text copy is specced to run around a headline that contains a rule above it (called an **overscore**). The headline is set on three lines, all set flush left, ragged right. The text copy is set justified. The overscore is set to match the column width.

The 12-point text type relates well to the 24-point display type because the baseline of every other line of text aligns with a baseline of display.

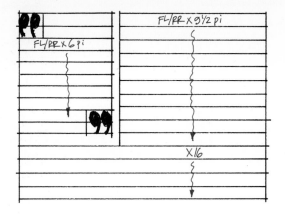

Thumbnail

32pt ITC GARA. ULTRA PER LAYOUT —

8/8 X 6 FL/RR ITC GARA. LT. WRAP COPY AROUND QUOTE MARKS PER LAYOUT

"Let those who are in favour with their stars of public honour and proud title boast, whilst I, whom good triumphs bars, have unlook'd for joy in that honour most shared." —32pt ITC GARA. ULTRA PER LAYOUT.

10/10 X16 FL/RR ITC GARA. LT. INDENT 1st 10 ll X 7pi PER LAYOUT

[Mine eyes hath play'd the painter and hath stell'd thy beauty's form in table of my heart; my body is the frame wherein 'tis held, and perspective it is best painter's art. For through the painter must you see his skill, to find where your true image pictured lies; which in my bosom's shop is hanging still, that hath his windows glazed in thine eyes. Now see what good turns eyes for eyes have done: mine eyes have drawn thy shape, and

" Let those who are in favour with their stars of public honour and proud title boast, whilst I, whom good triumphs bars, have unlook'd for joy in that honour most shared. "

Mine eyes hath play'd the painter and hath stell'd thy beauty's form in table of my heart; my body is the frame wherein 'tis held, and perspective it is best painter's art. For through the painter must you see his skill, to find where your true image pictured lies; which in my bosom's shop is hanging still, that hath his windows glazed in thine eyes. Now see what good turns eyes for eyes have done: mine

The top of this quotation set into text aligns with the top of the text type. The quote's last baseline aligns with the text's ninth baseline.

When inset into a block of copy, a quote can be treated like a headline, similar to the example shown on page 65. The quotation marks are set at four times the point size of the type in the quotation and this type is set in a size that is 2 points smaller than the text type.

The type sizes were selected according to their baseline-to-baseline relationships. Nine lines

of 10-point (text) increments add up to 90 points. Ten lines of 9-point (quotation) increments also add up to 90 points.

The two blocks of type are separated by a 1-pica space on the right and a full line space at the bottom.

SAFELY
IN HARBOUR
IS THE KING'S
SHIP

Thumbnail

				JUST. X 12 pi
				12
				4½
				4½
				4
				4
				14½
				14½
				17
				17
				17
				17
				17 to end

30/24 ITC GARA. BOLD
CAPS — FL/RR — 4ll

SAFELY⌐IN HARBOUR⌐IS THE KING'S⌐SHIP⌐

11/12 ITC GARA. LT.
JUST. X & LENGTHS
IN SKETCH.
ALIGN ON RT. SIDE

Full many a glorious morning have I seen flatter the mountaintops with
sovereign eye, kissing with golden face the meadows green, gilding pale
streams with heavenly alchemy; anon permit the basest clouds to ride with
ugly rack on his celestial face, and from the forlorn world his visage
hide, stealing unseen to the west with this disgrace: even so my sun one

SAFELY IN HARBOUR IS THE KING'S SHIP Full many a glorious morning have I seen flatter the mountaintops with sovereign eye, kissing with golden face the meadows green, gilding pale streams with heavenly alchemy; anon permit the basest clouds to ride with ugly rack on his celestial face, and from the forlorn world his visage hide, stealing unseen to the west with this disgrace: even so

A full-size comp is made to get basic size relationships worked out.
It is an accurate sketch, showing all baselines, display widths, and
text line lengths. For accuracy, the display type should be traced
from a sample book.

68

This runaround is complex because the display type is tucked into the text. For a good fit, the leading for the display type must align with the leading for the text. To determine line lengths, a full-size comp is created, and this comp is sent to the typesetter along with the marked-up manuscript. The spatial arrangement of the type is accurately traced from a type sample book; it indicates the width of the display type, the length of the text type, and the baselines.

The display type here is specced at 30/24 and the text type at 11/12. This leading permits both text and display to occupy the same depth. Eight lines of 12-point spacing (text) equal four lines of 24-point spacing (display).

Thumbnail

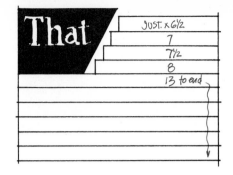

| | JUST. x 6½ |
| 7 |
| 7½ |
| 8 |
| 13 to end |

36pt ITC GARA. LT.
REVERSE VIDEO : SET
20pt BLACK ABOVE &
BELOW, 2 EMS BLACK
ON EITHER SIDE → (That

10/11 X 13 JUST.
ITC GARA. LT.
X LINE LENGTHS
ON LAYOUT—
ALIGN ON RT. EDGE.

[thou hast her, it is not all my grief, and yet it may be said I loved her
dearly; that she hath thee, is of my wailing chief, a loss in love that
touches me more nearly. Loving offenders, thus I will excuse ye: thou
dost love her, because thou know'st I love her; and for my sake even so

That thou hast her, it is not all my grief, and yet it may be said I loved her dearly; that she hath thee, is of my wailing chief, a loss in love that touches me more nearly. Loving offenders, thus I will excuse ye: thou dost love her, because thou know'st I love her; and for my

The first word is set in reverse video, or white on black. Any time you want white typography, get it set in reverse video to eliminate the intermediate step of a reverse photostat, which tends to round the edges of the letterforms slightly. Spec amount of black to be set above and below type.

Here the first word of a paragraph is set in **reverse video,** or white on black, and the text is specced to run around the black shape. The comp indicates the varying measures for the first three lines, lengthening by a ½ pica on each line, to create the diagonal runaround.

(Remember, send the typesetter a comp for anything that might be confusing in its peculiarity.)

The black portion of the reverse video type will be set with horizontal and vertical edges. To obtain the angle on the right-hand side, trim the type proof and paste it on the board. If the black area surrounding the type is not large enough, the reverse video type can be pasted on top of an inked-in shape of the desired size.

SO I AM AS THE RICH,
WHOSE ⊔⊔⊔ ⊔⊔⊔ ⊔ ⊔⊔⊔⊔
BLESSED ⊔⊔⊔⊔ ⊔⊔⊔ ⊔⊔⊔
KEY CAN ⊔⊔ ⊔⊔ ⊔⊔⊔⊔⊔
BRING HIM ⊔⊔ ⊔⊔⊔ ⊔⊔ ⊔⊔

Thumbnail

SO I AM AS THE RICH,
WHOSE ←————— 9pi —————→
BLESSED ←———— 9²/₃ ————→
KEY CAN ←——— 10¹/₃ ———→
BRING HIM ←———— 11 ————→

⊬ INDENT IN PTS.

24	JUST. × 8½pi
20	
16	
12	
8	
4	
0	

24/20 ITC GARA. LT. ITAL CAPS
FR/RL ℓ/ℓ
PER SKETCH ——→ [SO I AM AS THE RICH,]WHOSE [BLESSED [KEY CAN [BRING HIM [

10/10 × 8½ JUST.
ITC GARA LT. ITAL
FOLLOW SKETCH
FOR INDENTS.

[to his sweet up-locked treasure, to which he will not every hour survey, for blunting the fine point of seldom pleasure. Therefore are feasts so solemn and rare.

SO I AM AS THE RICH,
WHOSE *to his sweet up-locked*
BLESSED *treasure, to which he will*
not every hour survey,
KEY CAN *for blunting the fine*
point of seldom plea-
BRING HIM *sure. Therefore are feasts*
so solemn and rare.

To step multiple lines of copy so that they align, first establish baseline-to-baseline relationships, then work out the indentation relationship. Check the result on a tissue tracing.

70

In this example, display type wraps around the text type and both are indented in related incremental steps. First consider the depth of the columns of text and display. For this complex example to work, there must be a relationship between the baselines of both large- and small-size type. Here every second 10-point text baseline aligns with every 20-point display baseline.

The indentations must also be related in a two-to-one proportion. If every text line is indented 4 points, then two text lines will be indented a total of 8 points. Therefore every display line must be indented 8 points to match the indentations in the text type.

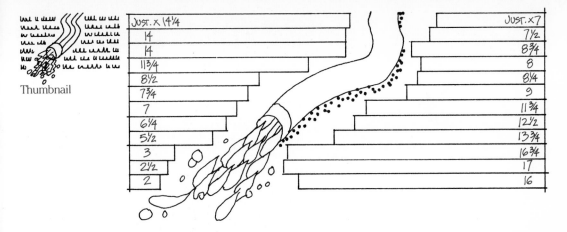

Thumbnail

JUST. × 14¼		JUST. × 7
14		7½
14		8¾
11¾		8
8½		8¼
7¾		9
7		11¾
6¼		12½
5½		13¾
3		16¾
2½		17
2		16

11/11 ITC GARA. LT. ⟶
PER LAYOUT

Why, is not this better than groaning for love? Now art thou sociable, now art thou Romeo; now art thou what thou art, by art as well as by nature. For this drivelling love is like a great natural that runs lolling up and down to hide his bauble in a hole. Stop there, stop there! Thou desirest me to stop in my tale against the hair. Thou wouldst else have made thy tale large. O, thou art deceived! I would have made it short; for I was come to the whole depth of my tale, and meant indeed to occupy the argument no longer. Here's goodly gear! A sail, a sail! Two, two! a shirt and a smock. Is not this better?

Why, is not this better than groaning thou sociable, now art thou Romeo; thou art, by art as well as by nature. is like a great natural that runs to hide his bauble in a there! Thou desirest against the hair. thy tale large. O, made it short; of my ment Two,

for love? Now art now art thou what For this drivelling love lolling up and down hole. Stop there, stop me to stop in my tale Thou wouldst else have made thou art deceived! I would have for I was come to the whole depth tale, and meant indeed to occupy the argu- no longer. Here's goodly gear! A sail, a sail! two! a shirt and smock. Is not this better?

The dual relationship of flush left/ragged right on one side of the picture and ragged left/flush right on the other side makes it essential that the typesetter be given a carefully drawn sketch (top right). Be prepared to make adjustments in the typesetting after the first pass.

This runaround follows the organic shape of the illustration *on both sides*. This is probably the most challenging kind of runaround setting you'll do. Half the text is set flush left, and half is set flush right. While it's possible to draw an accurate tracing and specify each line length, no amount of preplanning can determine exactly where the line breaks occur in the copy in order to jump the illustration.

Typically, adjustments have to be made by either the typesetter or the editor or by both. This costly procedure requires subtle spacing and hyphenation. Every adjustment made in one part of the type affects subsequent lines of type. It took three tries by the typesetter to get this one right.

Thumbnail

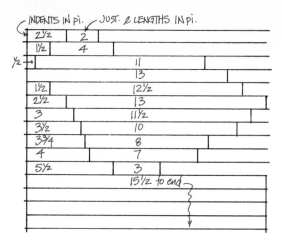

INDENTS IN PI. JUST. & LENGTHS IN PI.

2½	2		
1½	4		
½		11	
		13	
1½		12½	
2½		13	
3		11½	
3½		10	
3¾		8	
4		7	
5½		3	
		15½ to end	

10/10 × & LENGTHS
IN SKETCH: JUST.
ITC GARA. LT.
HYPHENS OK.

Being your slave, what should I do but tend upon the hours and times of
your desire? I have no precious time at all to spend, nor services to do,
till you require. Nor dare I chide the world-without-end hour whilst I,
my sovereign, watch the clock for you, nor think the bitterness of absence
sour when have bid your servant once adieu; nor dare I question with my
jealous thought where you may be, or your affairs suppose, but, like a sad

Being
your slave,
what should I do but tend upon
the hours and times of your desire? I
have no precious time at all to
spend, nor services to do, till you
require. Nor dare I chide the
world-without-end hour
whilst I, my sovereign,
watch the clock for
you, nor
think the bitterness of absence sour when
have bid your servant once adieu; nor dare I
question with my jealous thought where you

It is best to set type solid when creating a positive shape so that the
area of copy reads as a distinct shape on the page.

Every previous runaround example illustrates type that fits around another visual element–whether it's an illustration or display type. In the example above, the type itself is set in a positive shape recognizable as a dove. To set type in any positive-shaped configuration, keep the overall shape simple and the line lengths long enough to allow the typesetter flexibility in fitting words.

The process for specifying type to form a positive shape is the same as that used for any runaround. First, be sure to establish a vertical rule and to indicate all indentations line by line. Prepare a comp of the shape to determine the line lengths required to create the image.

Thumbnail

17½ pi OVERALL		
x 2¼	JUST. x \| 3 pi ULTRA	2¼
3	11½	3
4	9½	4
4¾	8	4¾
5½	6½	5½
6¼	5	6¼
7	3½	7
7¾	2	7¾
8¼	1	8¼

11/11 X 17½ JUST.
ITC GARA. LT. &
ULTRA – SET
PER COMP.

Thou wast never with me for anything when thou wast not there for the goose. I will bite thee by the ear for that jest. Nay, good goose, bite not! Thy wit is a very bitter sweeting; it is a most sharp sauce. And is it not, then, well served in to a sweet goose? O, here's a wit of cheveril, that stretches from an inch narrow to an ell broad! I stretch it out for the word 'broad'. Nay, if our wits run the

Thou **wast never with me for any**thing when th**ou wast not there for the** goose. I will bite **thee by the ear for** that jest. Nay, good go**ose, bite not! Thy** wit is a very bitter sweeting**; it is a most sh**arp sauce. And is it not, then, **well serve**d in to a sweet goose? O, here's a **wit of c**heveril, that stretches from an inch na**rro**w to an ell broad! I stretch it out for the **w**ord 'broad.' Nay, if our

Choose two typefaces that contrast well. Then supply all the line-by-line segments for the two faces and be prepared to readjust the breaks after the copy has been set the first time.

Here a block of continuous copy with a contained shape is defined by a contrasting weight of the same typeface.

As with many runarounds, the diagram showing line-length measurement is merely a starting point for the typesetter. The copy often fails to fit precisely in the allotted spaces. Word spaces tend to fall at undesirable places, or, as in this example, particularly wide letters seem to fall just where a break occurs between the light and the bold type. You will probably find it necessary to make some visual adjustments in word spacing, pushing some letters slightly to one side or the other. If this is done well, the reader will not be aware that any adjustments have been made.

Against my love shall be, as I am now, with time's injurious hand crush'd and o'erworn; when hours have drain'd his blood and fill'd his brow with lines and wrinkles; when his youthful morn hath travell'd on to age's steepy night, and all those beauties whereof now he's king are vanishing or vanish'd out of sight, steal-

Figure 1 is the most common kind of runaround we see. When one side is set flush, it is relatively easy to set well on the first pass—thus keeping costs down and frequency of use up.

Against my love shall be, as I am now, with time's injurious hand crush'd and o'erworn; when hours have drain'd his blood and fill'd his brow with lines and wrinkles; when his youthful morn hath travell'd on to age's steepy night, and all those beauties . . .

Name _____

Address _____

City _____ State _____

Zip _____

Figure 2 is particularly well used if the simple geometric shape is integral to the idea or design of the project. Be selective in your use of gimmicks such as this one. They can inadvertently grab the limelight and become the star of your design (when the message itself should be the star).

Against my love shall be, as I am now, with time's injurious hand crush'd and o'erworn; when hours have drain'd his blood and fill'd his brow with lines and wrinkles; when his youthful morn hath travell'd on to age's steepy night, and all those beauties whereof now he's king are vanishing or vanish'd out of sight, stealing away the treasure of his spring; for such a time do I now fortify against confounding age's cruel knife,

Figure 3 shows a clever way of connecting two areas of a layout. Imagine this type printed in several colors (or perhaps a gradation from light to dark).

Against my love shall be, as I am now, with time's injurious hand crush'd and o'erworn; when hours have drain'd his blood and fill'd his brow with lines and wrinkles; when his youthful morn hath travell'd on to age's steepy night, and all those beauties whereof now he's king are vanishing or vanish'd out of sight, stealing away the treasure of his spring; for such a time do I now fortify against confounding age's cruel knife, that he shall never cut from memory my sweet

Figure 4 is similar to Figure 3, only more wiggly, and with justified line lengths. The speccing procedure in both examples is also similar.

Here are four exercises to test your skills. Create the diagrams the typesetter would need to produce these results. Follow the style and degree of detail shown in the diagrams throughout the pages in this section. Remember to resolve these questions in your sketches:

- What is the baseline structure?
- What is the column width?
- What are the line-by-line indents?

Provide this information in a graphic way. The figures and instructions in your diagrams should be clear enough for someone to follow—easily.

Figure 1: The column on the left represents running text with no breaks. Inserting initial caps breaks the text into manageable pieces and provides spots of color at the same time (but don't overdo it).

That time of year thou mayst in me behold when yellow leaves, or none, or few, do hang upon those boughs which shake against the cold, bare ruin'd choirs where late the sweet birds sang. In me

Figure 2: Raised initials (also called upstanding or stick-up initials) rise above the top of the text.

When thou reviewest this, thou dost review the very part was consecrate to thee: the earth can have but earth, which is his due; my spirit is thine, the better part of me: so then thou hast but lost the dregs of life, the prey of worms, my body being dead, the coward conquest of a wretch's knife, too base of thee to be remembered. The worth

Figure 3: Drop caps (also called cut-in initials) are set into the text.

Initial caps

Large initial letters set into text typography are called **initial caps.** There are two reasons you might wish to use initial caps: to help the reader find the beginning of the text and to break up the grayness of long blocks of copy.

Initial caps introduce spots of color and character to the text. They can be used to start a story, or they can be used within it.

Initial caps can be great fun to design because they are simple elements that provide limitless opportunities for experimentation.

Initial caps come in two forms: **raised initials,** which rise above the top of the text (Figure 2), and **drop caps,** which are set into the copy and align with the top of the text (Figure 3).

they had not skill enough your worth to sing: for we, which now behold these present days, have eyes and ears to wonder, but lack tongues to praise.

sing: for we, which now behold these present days, have eyes and ears to wonder, but lack tongues to praise.

Not mine own fears, nor the prophetic soul of the wide world dreaming on things to come, can yet the lease of my true love control, supposed as forfeit to a confined doom. The mortal moon hath her eclipse endured and the sad augurs mock their own presage; in-

Not mine own fears, nor the prophetic soul of the wide world dreaming on things to come, can yet the lease of my true love control, supposed as forfeit to a confined doom. The mortal moon hath her eclipse endured and the sad augurs mock their own presage; in-

Figure 1: Leave space above an initial cap for greater visibility.

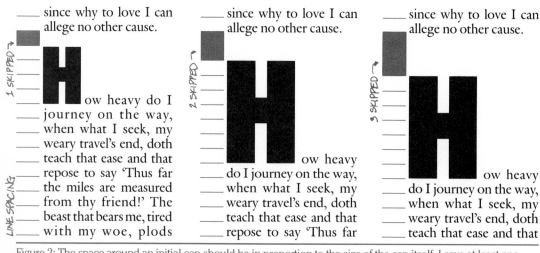

Figure 2: The space around an initial cap should be in proportion to the size of the cap itself. Leave at least one line space above small raised initials and at least two line spaces above larger raised initials.

A raised initial looks best when there is extra space surrounding it. This is achieved by inserting one or more line spaces above the initial (Figure 1). As the size of the raised initial is increased, the amount of space surrounding it should also be increased (Figure 2). Small initials require one line space, and larger initials should have two or more line spaces left open.

Simply mark the copy at the appropriate locations, "leave 1 line space" or "leave 2 line spaces." Unless marked, the copy will be set without any line spaces.

More fell than anguish, hunger, or the sea! Look on the tragic loading of this bed; this is thy work. The object poisons sight; let it be hid. Gratiano, keep the house,

More fell than anguish, hunger, or the sea! Look on the tragic loading of this bed; this is thy work. The object poisons sight; let it be hid. Gratiano, keep the house, and seize upon

More fell than anguish, hunger, or the sea! Look on the tragic loading of this bed; this is thy work. The object poisons sight; let it be hid. Gratiano, keep the house, and seize upon the fortunes of the

Figure 1: The baseline of an initial cap must align with one of the text's baselines. Specify which baseline aligns with the initial cap (first, second, third).

Let me not name it to you, you chaste stars! – It is the cause. Yet I'll not shed her blood; nor scar that whiter skin of hers than snow, and smooth as mon-

Figure 2: When an initial cap is the first letter of a word, the remaining letters of the word should be set closer to the initial than the indented lines below so that the word becomes recognizable. See Figure 2, page 78, for spec.

I pray you, in your letters, when you shall these unlucky deeds relate, speak of me as I am; nothing extenuate, nor set down aught in malice. Then must you speak of one that loved not wisely but too well; of one not easily jealous, but being wrought perplex'd in the extreme; of one whose hand, like the base Indian, threw a pearl away richer than all his tribe; of one whose subdued eyes, albeit unused

Figure 3: When an initial cap is a freestanding, separate word, set all lines farther from the initial to avoid confusion.

CONSISTENT → OPTICAL SPACING

Behold, I have a weapon; a better never did itself sustain upon a soldier's thigh. I have seen the day, that, with this little arm and this good sword, I have made my way

Figure 4: The space under and next to an initial cap should look fairly equal. Spec this by describing what you want in words and by providing a sketch.

Pale as thy smock!" When we shall meet at compt, this look of thine will hurl my soul from heaven, and fiends will snatch at it. Cold, cold,

Figure 5: Delete the opening quotation mark when setting an initial that begins a quote.

To produce the proper harmony between the initial and the text surrounding it, align the baseline of the initial cap with one of the text baselines (Figure 1).

If the initial cap is the first letter of a word, the rest of the word should follow it closely, but the other lines of text should be set a little farther away from the initial so they are read as separate words (Figure 2). If the initial cap is a word by itself, leave extra space between it and all lines of text (Figure 3).

The space surrounding an initial cap should be optically consistent. The space under the letter should look as deep as the space next to the letter (Figure 4).

If an initial cap is at the start of a quote, delete the opening quotation mark (Figure 5).

Thumbnails

ALL TEXT:
10/11 × 7½ FL/RR
ITC GALLIARD ROMAN

60 pt MORTISED INITIAL;
BASE-ALIGN 4TH ℓ
OF TEXT, HANG SERIF

Ⓐ murder, which I thought a sacrifice: I saw the handkerchief. He found
it then; I never gave it him. Send for him hither; let him confess a

60 pt SQ. CUT-IN INITIAL;
BASE-ALIGN 4TH ℓ
OF TEXT, HANG SERIF

Ⓐ murder, which I thought a sacrifice: I saw the handkerchief. He found
it then; I never gave it him. Send for him hither; let him confess a

60 pt MORTISED INITIAL;
BASE-ALIGN 4TH ℓ
OF TEXT, HANG
SERIFS & KERN 1st ℓ TO VERTICAL STROKE OF INITIAL

Ⓛet me not name it to you, you chaste stars! - It is the cause. Yet I'll
not shed her blood; nor scar that whiter skin of hers than snow, and smooth

60 pt SQ. CUT-IN →
BASE-ALIGN 4TH ℓ
OF TEXT, HANG SERIFS

Ⓛet me not name it to you, you chaste stars! - It is the cause. Yet I'll
not shed her blood; nor scar that whiter skin of hers than snow, and smooth

A murder, which
I thought a
sacrifice: I
saw the
handkerchief. He
found it then; I never
gave it him. Send for
him hither; let him

A murder,
which I
thought a
sacrifice: I
saw the handker-
chief. He found it
then; I never gave it
him. Send for him

L et me not name it
to you, you
chaste
stars!–It is
the cause. Yet I'll not
shed her blood; nor
scar that whiter skin
of hers than snow,

L et me not
name it to
you, you
chaste
stars!–It is the cause.
Yet I'll not shed her
blood; nor scar that
whiter skin of hers

This pair of initial cap *A*'s is set mortised and with a square cut-in. Setting the text mortised around the initial requires a per-line count just like runarounds (see pages 62-71).

This pair of initial cap *L*'s is set mortised and with a square cut-in.

78

Depending on the shape of the initial cap, the text can be set as a square cut-in or wrapped around (mortised). The text arrangement that follows the stick-up initial is particularly apparent with letters that are open at the lower right corner *(F, P, T, V, W,* and *Y)* or that are open at the upper right corner *(A* and *L)*.

Compare the examples shown above: a pair of initial caps set with the text mortised and a pair set with the text squared-off. This simple change affects the style of the printed piece.

To spec a square cut-in, you can simply write, "60 pt. drop cap, square cut-in." The typesetter determines the width of the space for the initial by measuring the width of the letter.

To spec a mortised initial, measure out each line and mark the copy with the desired line length, just as you would for a runaround.

Thumbnails

| JUST. x 6½ pi |
| 6¾ |
| 7½ |
| 8½ |
| 9½ |
| 15 to end |

HELVETICA EX. COMPRESSED
1" CAP HT
10/11 X 6 FL/RR
ITC GALLIARD ROM.
KERN AT CAP.

(L)et them not live to taste this land's increase that would with treason
wound this fair land's peace! Now civil wounds are stopp'd, peace lives
again: that she may live long here, God say amen!

DNS. INITIAL
10/11 X 15 JUST.
ITC GALLIARD ROM.
SET PER SKETCH,
ALIGN ON RT. SIDE.

(O)ne raised in blood, and one in blood establish'd; one that made means to
come by what he hath, and yet slaughter'd those that were the means to
help him. A base foul stone, made precious by the foil of England's chair,
where he is falsely set; one that hath ever been God's enemy. Then, if
you fight against God's enemy, God will in justice ward you as his
soldiers. If you do sweat to put a tyrant down, you sleep in peace, the

Let them not
live to taste this
land's increase
that would with
treason wound
this fair land's
peace! Now civil
wounds are
stopp'd, peace lives

Figure 1: The left edge of this stick-up initial aligns naturally with the left edge of the text.

One raised in blood, and one in blood establish'd; one that made means to come by what he hath, and yet slaughter'd those that were the means to help him. A base foul stone, made precious by the foil of England's chair, where he is falsely set; one that hath ever been God's enemy. Then, if you fight against God's enemy, God will in justice ward you as his soldiers. If you do sweat to put a tyrant

Figure 2: Round letters, when used as large initial caps, should extend slightly beyond the left edge of the text.

Because initial caps are meant to be easily seen, any flaws in their application will be particularly evident to the reader. Alignments are critical to the success of initial caps. Locating the left edge of the initial so it is visually aligned with the flush edge of the text is easy in Figure 1. In Figure 2, however, the alignment is less obvious.

The *O* in Figure 2 extends slightly beyond the left edge of the text. All other letters with round sides *(C, G, Q,* and *S)* should be handled in a similar manner. They should be pushed a little into the

margin. Because the *O* in this example is original art, a wraparound diagram was made to determine line lengths. If the *O* had been typeset, it would have been necessary to instruct the typesetter to "hang" the initial cap in the left-hand margin in order to achieve correct optical alignment. This distance, an estimate based on good judgment, is indicated in points.

They would restrain the one, distain the other. And who doth lead them but a paltry fellow, long kept in Bretagne at our mother's cost? A milksop, one that never in his

19 pts

Yet remember this, God and our good cause fight upon our side. The right prayers of holy saints and wronged souls, like high-rear'd bulwarks, stand before our faces;

21 pts

Villain, yet I lie, I am not. Fool, of thyself speak well: fool, do not flatter. My conscience hath a thousand several tongues, and every tongue brings in a several tale,

25 pts

What shall I say more than I have inferr'd? Remember whom you are to cope withal; a sort of vagabonds, rascals, and runaways, a scum of

22 pts

Jockey of Norfolk, be not too bold, for Dickon thy master is bought and sold." A thing devised by the enemy. Go gentlemen, every man unto his charge. Let not our babbling dreams affright our

12 pts

A battle shall be ordered. My forward shall be drawn out all in length, consisting equally of horse and foot. Our archers shall be placed in the midst: John Duke of Norfolk, Thomas

7 pts

These letters need special handling because of their particular shapes. There is no formula to follow, because typefaces and shapes vary so widely. Here, for clarity, the *T, Y,* and *V* are positioned with their vertical axes aligned on the left-hand edge of the text. The *W* aligns on its left elbow. The *J* and *A* are optically aligned.

80 Other letters requiring special vertical alignment are *J, T, V, W, A,* and *Y.* Each has an optical peculiarity on one or both sides of the letterform. *J* is weak on the left side and should be pushed slightly out to the left; *A, V, W,* and *Y* are strongly angled and should stick out at the left to create a visually vertical edge.

The capital *T* is a special case because *The* begins sentences so often. The vertical stroke should be positioned flush left with the text so that the horizontal stroke cantilevers into the margin.

The typesetter needs to know the distance of the overhang into the margin for each letter. Specify this in points, or describe what portion of the letter should stick out into the margin. Then determine the line lengths for the runaround.

Thumbnails

Gazing on that which seems to dim thy sight? What seest thou there? King Henry's diadem, enchased with all the honours of the world? If so, gaze on, and grovel on thy face, until thy head be circled with the same. Put forth thy hand, reach at the glorious gold. What, is't too short? I'll

24pt STICK-UP INITIALS – KERN TEXT.

Presumptuous dame, ill-nurtured Eleanor, art thou not second woman in the realm, and the protector's wife? And wilt thou still be hammering treachery, to tumble down thy husband and thyself from top of honour to disgrace's feet? Away from me, and let me hear no more! What, what, my lord! are you so choleric with Eleanor, for telling but her dream?

g azing on that which seems to dim thy sight? What seest thou there? King Henry's diadem, enchased with all the honours of the world? If so, gaze on, and grovel on thy face, until thy head be circled with the same. Put forth thy hand, reach at

Figure 1: An enormous lowercase letter is used as an initial. Optical alignment of the left edge of the letterform with the text is important.

P resumptuous dame, ill-nurtured Eleanor, art thou not second woman in the realm, and the protector's wife?

A nd wilt thou still be hammering treachery, to tumble down thy husband and thyself from top of honour to disgrace's feet? Away from me, and let me hear no more!

W hat, what, my lord! are you so choleric with Eleanor, for telling but her dream?

Figure 2: Smaller initials can be used more frequently because they take up less space. Be sure to allow enough space between the top of the cap and the descenders/baseline of the preceding line of text. Otherwise, the letters will overlap.

Consider the individual features of each initial cap in determining spatial relationships. For example, Figure 1 shows an enormous lowercase stick-up initial positioned so the bowls optically align with the left edge of the justified text. Actually, the initial extends slightly beyond the edge.

On the other hand, Figure 2 has small stick-up initial caps in narrow columns of flush right/ragged left text. Notice how inviting the copy looks. It has been effectively broken into pieces.

Thumbnails

and all is borne away, ready to starve and dare not touch his own. So York must sit and fret and bite his tongue, while his own lands are bargain'd for and sold anon.

England, France and Ireland bear that proportion to my flesh and blood as did the fatal brand Althaea burn'd unto the prince's heart of Calydon. Anjou and Maine both given unto the French! Cold news for me, for I had hope of France, even as I have of fertile England's soil. A day will come when York shall claim his own; and therefore I will take the Nevils' parts

England, France and Ireland bear that proportion to my flesh and blood as did the fatal brand Althaea burn'd unto the prince's heart of Calydon. Anjou and Maine both given unto the French! Cold news for me, for I had hope of France, even as I have of fertile England's soil. A day will come when York shall claim his own; and therefore I will take the Nevils' parts

touch his own. So York must sit and fret and bite his tongue, while his own lands are bargain'd for and sold anon.

ngland, France and Ireland bear that proportion to my flesh and blood as did the fatal brand Althaea burn'd unto the prince's heart of Calydon. Anjou and Maine both given unto the French! Cold news for me, for I had hope of France, even as I have of fertile England's soil. A day will come when York shall claim his own; and therefore I will take the Nevils'

Figure 1: An initial cap set very tightly into the text, this example shows extremely precise alignments between text and initial. This technique is especially appropriate for initials added as art on the mechanical. Notice that the initial was not set as part of the text.

NGLAND, FRANCE AND IRELAND bear that proportion to my flesh and blood as did the fatal brand Althaea burn'd unto the prince's heart of Calydon. Anjou and Maine both given unto the French! Cold news for me, for I had hope of France, even as I have of fertile England's soil. A day will come when York shall claim his own; and there-

Figure 2: This large, three-dimensional initial aligns with the text at its back edge. The caps act as a transition between the initial and the remaining text.

Although space is normally allowed between an initial and the text, interesting effects can also be achieved if some space between these elements is eliminated.

Figure 1 is an example showing intentionally tight space surrounding an initial cap. There are no additional line spaces above the initial, and the text is set very close to the initial's right side. The top of the initial aligns with the top of the x-height

on the first cut-in text line, and the initial's baseline aligns with the baseline of the fourth cut-in line of text.

Figure 2 illustrates an initial cap that exaggerates the scale between it and the text. Note that the first few words of text are set in caps (a lead-in), another variation in handling initial caps with text type.

S Thumbnails **S**

60pt ITC FENICE REG.
HANG INITIAL & ALIGN
TOP WITH TOPS OF
ASCENDERS.
SET TEXT 10/11 X13
FL/RR FENICE REG.

Sometimes lurk I in a gossip's bowl, in very likeness of a roasted crab, and when she drinks against her lips I bob, and on her withered dewlap pour the ale. The wisest aunt, telling the saddest tale, sometime for three-foot stool mistaketh me: then slip I from her bum, down topples she, and 'tailor' cries, and falls into a cough. And then the whole choir hold

60pt ITC FENICE REG.
HANG INITIAL &
ALIGN BASELINE
WITH 1st l OF TEXT.
SET TEXT 10/11 X13
FL/RR FENICE REG.

Sometimes lurk I in a gossip's bowl, in very likeness of a roasted crab, and when she drinks against her lips I bob, and on her withered dewlap pour the ale. The wisest aunt, telling the saddest tale, sometime for

Sometimes lurk I in a gossip's bowl, in very likeness of a roasted crab, and when she drinks against her lips I bob, and on her withered dewlap pour the ale. The wisest aunt, telling the saddest tale, sometime for three-foot stool mistaketh me: then slip I from her bum, down topples she, and 'tailor' cries,

Figure 1: Hanging initials stand in the left margin. Try to avoid using an *A* because its top is too far from the beginning of the text.

Sometimes lurk I in a gossip's bowl, in very likeness of a roasted crab, and when she drinks against her lips I bob, and on her withered dewlap pour the ale. The wisest aunt, telling the saddest

Figure 2: Here the baseline of the initial is shared by the first line of text.

A **hanging initial** is an initial placed in the margin to the left of the text. Clearly, all hanging initials need wide margins. This generous use of white space makes them an excellent alternative to raised caps or tightly set drop caps.

Figure 1 shows the most common form of hanging initial. In this style, the top of the initial aligns with the tops of the ascenders of the first line of text.

Figure 2 shows a hanging initial sharing its baseline with the first line of text. This style is ideal if you are using the initial cap only once, to begin the copy. Notice that the text has been set flush left. If the initial is itself a word *(A or I)*, leave a bit more space between it and the text to act as a word space.

B [thumbnail lettering] **B** [thumbnail lettering]

72 pt CENTURY ULTRA COND.
INITIAL CAP - ALIGN TOP
WITH TOPS OF ASCENDERS

SET TEXT 10/11 x 11
ITC FENICE REG.
FL/RR - HANG
1st l 1¾ pi.

Because that she as her attendant hath a lovely boy, stolen from an Indian king; she never had so sweet a changling; and jealous Oberon would have the child knight of his train, to trace the forests wild. But she perforce withholds the loved boy, crowns him with flowers and makes him all her joy: and now they never meet in grove or green, by fountain clear, or

72 pt HELV. BLK. EXPANDED
INITIAL CAP - BASE-ALIGN 3 pt RULE x WIDTH OF 1st l 2 pt # ABOVE INITIAL CAP

SET TEXT 10/11 x 10
ITC FENICE REG.
FL/RR - HANG
1st l 2½ pi.

Because that she as her attendant hath a lovely boy, stolen from an Indian king; she never had so sweet a changling; and jealous Oberon would have the child knight of his train, to trace the forests wild. But she perforce withholds the loved boy, crowns him with flowers and makes him all

Because that she as her attendant hath a lovely boy, stolen from an Indian king; she never had so sweet a changling; and jealous Oberon would have the child knight of his train, to trace the forests wild. But she perforce withholds the loved boy, crowns him with flowers and makes him all her joy: and

Figure 1: A hanging initial is combined with a hanging indent. This style saves space because it is not necessary to leave line spaces between paragraphs. On the other hand, more space is required in the margin than for either style shown on page 76.

Because that she as her attendant hath a lovely boy, stolen from an Indian king; she never had so sweet a changling; and jealous Oberon would have the child knight of his train, to trace the forests wild. But she

Figure 2: A hanging initial/indent combination is shown with a horizontal overscore. Although the initial can be typeset together with the text, it is often easier to position it yourself on the mechanical board.

A hanging initial attached to the beginning of a hanging indent (see page 47) calls for proper alignments. Instruct the typesetter to align the top of the initial with the tops of the ascenders on the first line of text.

Figure 2 shows another hanging initial/indent combination. Here the baseline of the initial aligns with the baseline of the text, and the 3-point horizontal rule matches the overall width of the first line of type.

It is often easier and less expensive to add the initial caps on the mechanical rather than having them set in position with the text type. In fact, you may acquire the initial cap from another source entirely, from a sheet of rub-down letters, perhaps, or from clip art.

Thumbnails

9/10 X 16 JUST.
ITC QUORUM BK.
INDENT 1st 4ll
x6½ pi

Vaunt in their youthful sap, at height decrease, and wear their brave state out of memory. Then the conceit of this inconstant stay sets you most rich in youth before my sight, where wasteful Time debateth with Decay, to change your day of youth to sullied night; and all in war with Time for love of you, as he takes from you, I engraft you new. But wherefore do not you a mightier way make war upon this bloody tyrant, Time? And fortify

9/10 X 16 JUST.
ITC QUORUM BK.
INDENT 1st 6ll
x 8½ pi

Vaunt in their youthful sap, at height decrease, and wear their brave state out of memory. Then the conceit of this inconstant stay sets you most rich in youth before my sight, where wasteful Time debateth with Decay, to change your day of youth to sullied night; and all in war with Time for love of you, as he takes from you, I engraft you new. But wherefore do

aunt in their youthful sap, at height decrease, and wear their brave state out of memory. Then the conceit of this inconstant stay sets you most rich in youth before my sight, where wasteful Time debateth with Decay, to change your day of youth to sullied night; and all in war with Time for love of you, as he takes from you, I engraft you new. But wherefore do not you a mightier way make war upon this

Figure 1: This simple cut-in initial uses custom-made artwork. Spec the type for a square cut-in and add the initial on the mechanical.

aunt in their youthful sap, at height decrease, and wear their brave state out of memory. Then the conceit of this inconstant stay sets you most rich in youth before my sight, where wasteful Time debateth with Decay, to change your day of youth to sullied night; and all in war with Time for love of you, as he takes from you, I

Figure 2: This is another simple cut-in, done to a greater depth. Delete the initial cap on the manuscript before having the copy set.

The initial caps on this page are custom-made pieces of artwork generated from a computer. In Figure 1 the first four lines of text are cut in 6½ picas to fit the artwork, which measures 6 picas wide. The remaining lines of text are justified across a full measure of 16 picas. Because the artwork is custom made, it is inserted on the mechanical.

Figure 2 is cut in 8½ picas for the first six lines of text. The column width happens to be the same as in Figure 1, 16 picas. The 8-pica-wide artwork is added on the mechanical, with careful alignment of the baselines and the left edges of text and art.

Remember to delete the initial letter on the manuscript when marking up copy for examples like this. The initials will be restored as artwork on the mechanical.

G *[thumbnail sketch with G initial and wavy lines representing text]* **G** *[thumbnail sketch with flourish and G initial]*

Thumbnails

[handwritten specification notes:]
60pt FUTURA EX. BLK. COND.
INITIAL CAP - INSERT 2pt # ⌐½pt RULE X 14
ABOVE CAP, HANG 2pt →
10/11 X 14 FL/RR
ITC ZAPF CHANCERY
MED. ITAL.

Gentlewoman, mild and beautiful! I hope my master's suit will be but cold,
since she respects my mistress' love so much. Alas, how love can trifle
with itself! Here is her picture: let me see; I think, if I had such a
tire, this face of mine were full as lovely as is this of hers. And yet

[handwritten specification notes:]
48pt ITC ZAPF CHANCERY MED. ITAL.
INITIAL CAP - NO
SWASH, USE ALTERNATE
CHARACTER.
TEXT: 10/11 X 16½
FL/RR ITC ZAPF
CHANCERY MED.
ITAL: INDENT 1st
3ll X 11 pi

Gentlewoman, mild and beautiful! I hope my master's suit will be but cold,
since she respects my mistress' love so much. Alas, how love can trifle
with itself! Here is her picture: let me see; I think, if I had such a
tire, this face of mine were full as lovely as is this of hers. And yet
the painter flatter'd her a little, unless I flatter with myself too much.

G*entlewoman, mild and beautiful!
I hope my master's suit will be but cold, since
she respects my mistress' love so much. Alas,
how love can trifle with itself! Here is her pic-
ture: let me see; I think, if I had such a tire,*

Figure 1: A bold initial combined with a light rule. Be sure the left edge of round letters is optically aligned with the left edge of the text. (Notice that the initial sticks out at the left slightly.)

[flourish illustration with G initial] **G***entlewoman, mild
and beautiful! I
hope my master's
suit will be but cold, since she respects my mistress'
love so much. Alas, how love can trifle with itself!
Here is her picture: let me see; I think, if I had such a
tire, this face of mine were full as lovely as is this of
hers. And yet the painter flatter'd her a little, unless I*

Figure 2: Here the text has been deeply indented to accommodate a large initial and added flourish. Any artwork or photo can be inserted in this space.

Figure 1 shows a bold initial combined with a light horizontal rule set across the full column width. This combination creates contrast, which is further emphasized by the white space above the text. Be sure to specify how much space (in points) is to be left between the rule and the top of the initial.

Figure 2 shows an especially deep indent for the first three lines of text type, which allows room for an ordinary large initial and a flourish. Any sort of illustration may be inserted into the space. It is easiest to add the artwork on the mechanical. In this case, the artwork was made later to fit the space. The type specification called for an indent of 11 picas to accommodate both the initial cap and the illustration. Always accompany the manuscript with a thumbnail sketch.

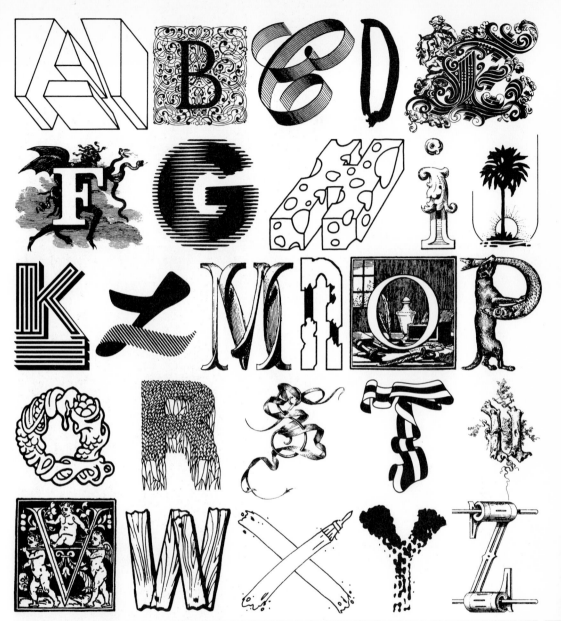

Shown here are samples of decorative alphabets readily available as artwork for initial caps. Most are taken from a series of inexpensive softcover books published by Dover Publications, Inc., New York. The illustrations are copyright free, which means that they may be used without permission or payment. Collections such as these are available at art-supply stores, through most bookshops, or by catalog directly from the publisher.

In addition, original letterforms can be drawn by hand or made on the computer. Exploring sources and using your own ingenuity can lead to unique and interesting solutions, but good taste and artistic insight must guide the decision. It is easy to overdo. Remember the adage, "When in doubt, throw it out."

	FOR	AGAINST
ESCALUS	120	24
PARIS	18	26
MONTAGUE	98	46
NURSE	77	67
JULIET	32	12
TYBALT	51	93
ROMEO	94	50

Tables present information in type that is arranged in columns.

Deaths per play

THE GLOBE THEATRE **PROPS REPORT** STRATFORD UPON AVON

CHECKED BY: DATE:

PART NUMBER:

Forms provide spaces into which information can be inserted.

Charts and graphs display quantifiable relationships with pictorial images.

TABLES

Tables and forms are often confused with charts and graphs. **Tables** are typographic displays of data arranged in columns. **Forms** are documents with blanks designed for the insertion of information (see page 92), and **charts** and **graphs** are pictorial images used to show quantifiable relationships (see page 95).

Traditional phototypesetting equipment is capable of setting horizontal rules easily. Vertical rules require much more complicated maneuvers.

However, **digital typesetting** equipment, which creates letterforms from electronic information rather than from a film negative, can set both horizontal and vertical rules easily and with precise spacing.

The manuscript is marked with appropriate specs and is always accompanied by a comp, which the typesetter follows for the proper placement of the elements.

	FOR	AGAINST
ESCALUS	12	24
PARIS	18	26
MONTAGUE	98	46
NURSE	77	67
JULIET	32	12
TYBALT	51	93
ROMEO	94	50

Thumbnail

	FOR	AGAINST
ESCALUS	12	24
PARIS	18	26
MONTAGUE	98	46
NURSE	77	67
JULIET	32	12
TYBALT	51	93
ROMEO	94	50

This table emphasizes horizontal relationships. Flush left alignment of tabular material, such as the numerical information in this figure, is neater and easier to read than a similar table using centered columnar alignments.

Information in tables is arranged so that a new piece of information appears at the intersection of two axes. It is usually necessary to design a table with either a vertical or a horizontal emphasis, a decision based on the nature of the information and the relationships you wish to emphasize among the table's elements. In this table, Escalus, 120, and 24 are more important as a group than Escalus, Paris, and Montague. The horizontal rule helps unite the three elements on each line. The chart on page 90 has a vertical emphasis. Note how the numbers are easiest to read in a vertical direction.

Speccing a table begins with thumbnails and full-size roughs. Trial and error with a Haberule will determine leading increments and horizontal spacing between elements. Tables larger than the ones shown on these pages follow the same procedures and are more complex simply because they have more pieces. There are no shortcuts to this process.

Number of actors per scene

	Scene i	Scene ii	Scene iii	Scene iv	Scene v	Scene vi
Act I	25	16	33	16	27	—
Act II	10	21	15	35	29	18
Act III	30	28	11	19	13	-
Act IV	16	14	26	18	15	—

Thumbnail

8pt RULE
13pt #
2pt RULE
ALL TYPE: 8/13 FUTURA BOLD COND.
4½"
11pt GARA. LT. CENTERED
13pt # BETWEEN RULES
F.R.
4pi
CENTER COLUMNS
½pt RULES × 4½"

Number of actors per scene

	Scene i	Scene ii	Scene iii	Scene iv	Scene v	Scene vi
Act I	25	16	33	16	27	—
Act II	10	21	15	35	29	18
Act III	30	28	11	19	13	—
Act IV	16	14	26	18	15	—

Number of actors per scene

	Scene i	Scene ii	Scene iii	Scene iv	Scene v	Scene vi
Act I	25	16	33	16	27	—
Act II	10	21	15	35	29	18
Act III	30	28	11	19	13	—
Act IV	16	14	26	18	15	—

This table emphasizes vertical relationships. The use of rules adds visual interest.

90

Designing tables can be an arbitrary exercise. Work until you get the design you like. To spec a table for typesetting, figure leading increments and then the horizontal spacing between elements.

This table's overall width is 27 picas. The information in the far left-hand column occupies 3 picas, leaving 24 picas for the columns of numerical information. Dividing 24 picas by six columns, we find that each column should be centered in 4 pica increments. (Notice these columns are set centered and the columns on the previous page are set flush left. This is a choice you must make for any table.)

The middle sketch was sent to the typesetter exactly as you see it here. It acted as both manuscript and comp. Supplying the typesetter with a full set of dimension marks yields a single piece of typeset copy, which can be pasted in position on a mechanical with no further alterations.

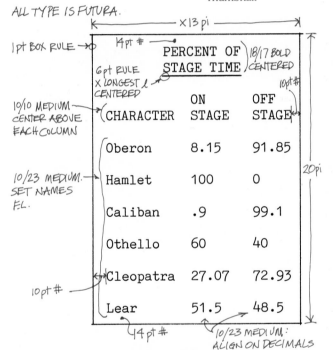

ALL TYPE IS FUTURA.

PERCENT OF STAGE TIME

CHARACTER	ON STAGE	OFF STAGE
Oberon	8.15	91.85
Hamlet	100	0
Caliban	.9	99.1
Othello	60	40
Cleopatra	27.07	72.93
Lear	51.5	48.5

Thumbnail

Annotations: × 13 pi · 1 pt BOX RULE · 14 pt # · 18/17 BOLD CENTERED · 6 pt RULE X LONGEST l CENTERED · 10 pt # · 10/10 MEDIUM CENTER ABOVE EACH COLUMN · 10/23 MEDIUM. SET NAMES F.L. · 20 pi · 10 pt # · 14 pt # · 10/23 MEDIUM: ALIGN ON DECIMALS

PERCENT OF STAGE TIME

CHARACTER	ON STAGE	OFF STAGE
Oberon	8.15	91.85
Hamlet	100	0
Caliban	.9	99.1
Othello	60	40
Cleopatra	27.07	72.93
Lear	51.5	48.5

Aligning tabular material on the decimal points is necessary when the numbers vary widely. Compare the clarity of the typeset and typewritten versions of this table. The primary difference is alignment on the decimals rather than aligning flush left.

This table shows an assortment of numerical values aligned on the decimal points. The arrangement makes comparisons between numbers easier than if they were aligned flush left or centered, because they are visually aligned on a common point. This is particularly true when some of the figures are shorter than others. Bigger numbers *look* bigger because they fall to the left of smaller numbers.

If aligning tabular material on the decimals still fails to create a clear connection among elements, you can tighten the leading or you can add horizontal or vertical rules or you can use **leaders** (.) between the elements.

NOTE: ALL TYPE IS ITC BENGUIAT CONDENSED

ALIGN TOPS 6pt # 28/21 BLD CENTERED

14/14 BK, CENTERED → THE GLOBE THEATRE PROPS REPORT STRATFORD UPON AVON ← 14/14 BK, CENTERED

ALIGN BOTTOMS

9pt BK ITAL, EL.

CHECKED BY: DATE:

½pt RULE × 10 6pt #

PART NUMBER:

26pt #

3pt #
3pt RULE × 17½

½pt RULE × 7

2" 15pt #

½pt RULE × 17½

6pt # ½pt BOX RULE

18½ pi

THE GLOBE THEATRE PROPS REPORT STRATFORD UPON AVON

CHECKED BY: DATE:

PART NUMBER:

Thumbnail

THE GLOBE THEATRE **PROPS REPORT** STRATFORD UPON AVON

CHECKED BY: DATE:

PART NUMBER:

A form has spaces for the insertion of information. Note the spacing specified between the instruction text and the corresponding rules. This is the critical feature affecting the design, because it influences how easily the form will be used.

92 FORMS

A form is a document with blank spaces designed for the insertion of information.

It is essential that a form be clear to the user. The words of instructions should clearly belong to the specific space the writer is asked to write in; it should "lead into" the space naturally. A colon can offer the first clue. The relationship to the rules above and below the wording is the second clue. Consider the rules not as baselines to draw on,

but rather as walls separating the spaces to be filled in with typewritten copy or handwriting.

This form did not require counting characters; there are so few. Type sizes were chosen simply for visual appeal.

The most logical and easy-to-understand location for instructional wording is flush left and well above its corresponding rule. This placement positions the wording in an expected place and leaves maximum room for writing.

Thumbnail

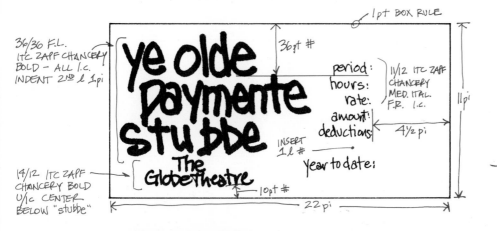

1pt BOX RULE

36/36 F.L.
ITC ZAPF CHANCERY
BOLD — ALL l.c.
INDENT 2ND l 1pi

36pt #

period:
hours:
rate:
amount:
deductions:

11/12 ITC ZAPF
CHANCERY
MED. ITAL.
F.R. l.c.

11pi

INSERT
1l #

4½ pi

year to date:

14/12 ITC ZAPF
CHANCERY BOLD
U/lc CENTER
BELOW "stubbe"

10pt #

22 pi

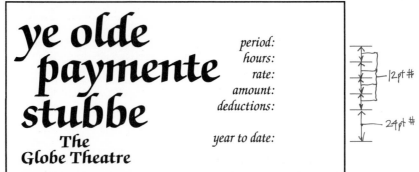

period:
hours:
rate:
amount:
deductions:

12pt #

year to date:

24pt #

When designing a form for use with a typewriter, pay particular attention to line spacing requirements and minimal tab settings. The form should be designed so all responses can be typed in flush left.

All forms should be designed with efficiency and the user's convenience in mind. Some forms are specifically made to accept typewritten information, which means that your design should anticipate this condition. Make a full-size comp of the form, photocopy it, and fill in the form using a typewriter to confirm that the spacing and placement of the elements work.

The baselines should be correctly placed so that the typist doesn't have to adjust the roller before typing each new line. The baselines of

typewriters are 12 points apart in the single-spacing mode, 18 points apart in the space-and-a-half mode, and 24 points apart in the double-spacing mode. These dimensions are the same for all kinds of typewriters.

Consider also the vertical alignment of elements. It is particularly helpful if you can place the elements so that the typist can return to the same margin with each new line without having to hunt for the appropriate space.

Thumbnail

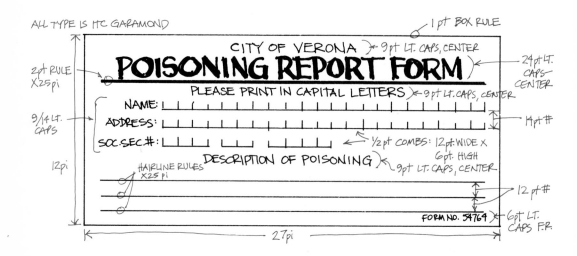

ALL TYPE IS ITC GARAMOND

1 pt BOX RULE

CITY OF VERONA — 9pt LT. CAPS, CENTER

POISONING REPORT FORM — 24 pt LT. CAPS CENTER

2pt RULE X25pi

PLEASE PRINT IN CAPITAL LETTERS — 9 pt LT. CAPS, CENTER

9/14 LT. CAPS

NAME:

ADDRESS:

SOC. SEC. #:

½ pt COMBS: 12 pt. WIDE X 6pt. HIGH — 9pt LT. CAPS, CENTER

14 pt #

12pi

HAIRLINE RULES X25 pi

DESCRIPTION OF POISONING

12 pt #

FORM NO. 54764 — 6pt LT. CAPS F.R.

27pi

CITY OF VERONA

POISONING REPORT FORM

PLEASE PRINT IN CAPITAL LETTERS

NAME:

ADDRESS:

SOC. SEC. #:

DESCRIPTION OF POISONING

FORM NO. 54764

An entire form can be set in one piece. The spaces where, in this case, the victim fills in information are called combs.

Many forms are designed to be filled in by hand. If the information is to be subsequently logged into a computer, it must often fit within a designated character count. **Combs** provide designated spaces for every character to control their number and placement within a form.

In specifying a comb, you may include as little information as the weight of the line desired (½ point is used in this example), or you may include additional information, such as the width of each space (in points) and the height of the vertical strokes (also in points). For example, each slot in the combs here is 12 points wide and 6 points high.

Thumbnail

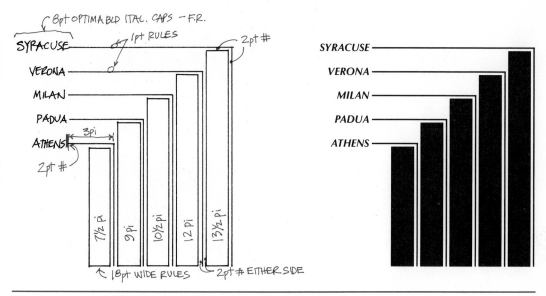

This pictorial image utilizes the typesetter's capability of setting both vertical and horizontal rules.

CHARTS AND GRAPHS

Charts and graphs are pictorial images used to show quantifiable relationships. Ordering type for a chart or graph requires slighlty different handling than does ordinary copy. Rather than setting a full line of copy at one time, line after line, the typesetter must attend to both side-to-side and up-and-down alignments, so be sure to provide *all* spacing dimensions.

The final design for this chart evolved from a series of thumbnails. The design was then enlarged to a full-size comp (on the left) and then – from this sketch – set in one piece. All specifications were established by measuring the comp. The vertical bars are 18-point rules. The lengths of the 1-point rules (running above and between the bars) were determined by the typesetter, based on the indicated dimensions.

Tomatoes per Capulet

Thumbnail

Specs (hand-written annotations):

- 3pt RULE x 22pi
- 22 pi (width)
- 22pt #
- 18pt ITC ISBELL BK, CENTER
- NUMBERS: 14/15 ITC ISBELL BOOK F.L. CENTER TOP/BOT.
- 15pt #
- 4 pi
- VERTICAL RULES: 1½pt
- HORIZONTAL RULES: ½pt
- 11/15 BULLETS CENTERED TOP/BOTTOM & SIDE/SIDE
- 2pt # ABOVE TYPE
- 10pt ITC ISBELL BK - CENTER BELOW EACH COL.

Tomatoes per Capulet

	Juliet	Lady	Tybalt	Sampson	Gregory
60					
50			●		
40			●	●	●
30			●	●	●
20	●		●	●	●
10	●	●	●	●	●

Here the bullet is used as a symbolic element. Partial shapes must be sliced off by a razor blade on the mechanical.

96 This chart makes prominent use of the bullet as the illustrative element. The roundness of the bullets here suggests tomatoes, but other ideas for round bullets come to mind. A chart on pea harvests (in green ink, of course) or a chart for a bowling ball manufacturer would make good use of a bullet's round form.

The chart's grid was designed first, and then the bullets were specced from a sample book. Bullets in 11 point were chosen because they fit comfortably within 15 points of vertical space. The typesetter set them directly in position from the specs indicated on the comp. Partial bullets were created on the board by slicing off the tops of full bullets, using a razor blade.

Thumbnail

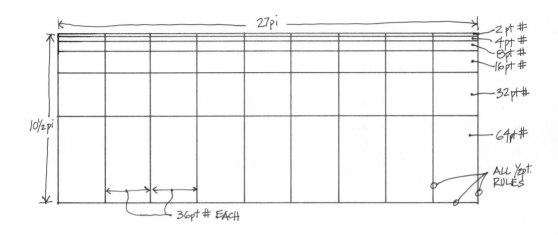

27 pi

10½ pi

2 pt #
4 pt #
8 pt #
16 pt #

32 pt #

64 pt #

ALL ½pt.
RULES

36pt # EACH

The typesetter can set vertical and horizontal rules only. The heavy diagonal line must be added on the mechanical. That is why the type spec comp (middle illustration) does not show the diagonal rule.

Although most typesetters can set both vertical and horizontal rules with digital equipment, diagonal rules cannot be handled with the same facility. The little stair-stepped edges (called "jaggies") that appear on digitized diagonal rules make hand-drawn lines on a mechanical preferable.

The example here was created by combining a typeset grid with a diagonal line hand-drawn on an acetate overlay. The comp sent to the typesetter (middle illustration) gives instructions for the spacing *between* elements, which are as important as the instructions for the rules themselves.

|606| •••••••••○•

Thumbnail

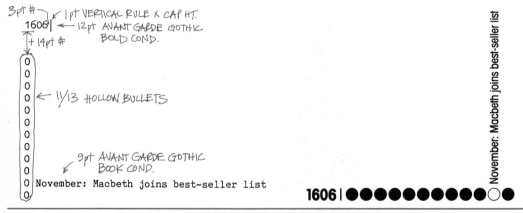

3pt # ⌐⟵ 1 pt VERTICAL RULE × CAP HT.

1606| ⟵ 12pt AVANT GARDE GOTHIC
 BOLD COND.

⊤+ 14pt #

0
0
0
0 ⟵ 11/13 HOLLOW BULLETS
0
0
0
0
0 9pt AVANT GARDE GOTHIC
0 ↙ BOOK COND.
0 November: Macbeth joins best-seller list
0

1606 | ●●●●●●●●●●○●

November: Macbeth joins best-seller list

Here bullets are used as imagery. The graph is tipped on its side for setting because typesetting equipment requires that type be set horizontally (middle illustration). The date is pasted in position on the mechanical.

98

In this graph, 11-point hollow bullets were specified and all but the eleventh one filled in by hand on the mechanical. Circular O's could be specified as well, but select a face that has truly round shapes, such as ITC Avant Garde, Bauhaus, or Kabel.

The typesetter cannot set type sideways except with great difficulty. For setting, therefore, the type was tipped on its side. The bullets were set vertically 11/13 flush left, with the copy ("November…") running horizontally from the eleventh bullet as shown in the middle illustration. The figure was returned to the desired angle and the date ("1606") pasted in position on the mechanical.

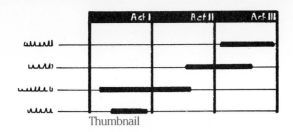

Thumbnail

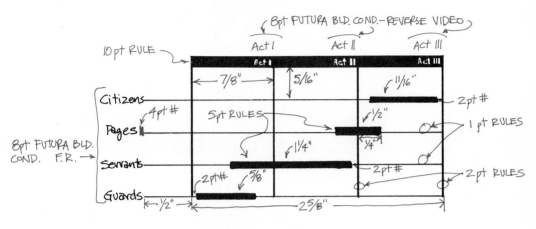

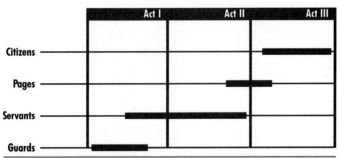

This chart can be set entirely in one piece, including the reverse video. Notice the necessity to indicate all spaces *between* elements as well as the weights and precise locations of each rule and typographic constituent.

In this chart, the horizontal bars represent periods of time that vary in length. The entire chart can be set in one piece with digital equipment. The white type "dropped out" of the black band (reverse video) is also created by the typesetter. When speccing the type, mark the copy for reverse video, but remember to take into consideration the size of the black area surrounding the type. In this case, 8-point type is reversed from a 10-point rule extending the width of the entire chart (2⅝ inches).

Thumbnail

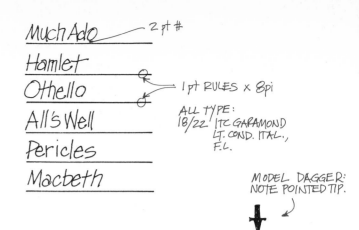

Much Ado — 2 pt #

Hamlet

Othello — 1 pt RULES × 8pi

All's Well

ALL TYPE:
18/22 ITC GARAMOND
LT. COND. ITAL.,
F.L.

Pericles

Macbeth

MODEL DAGGER:
NOTE POINTED TIP.

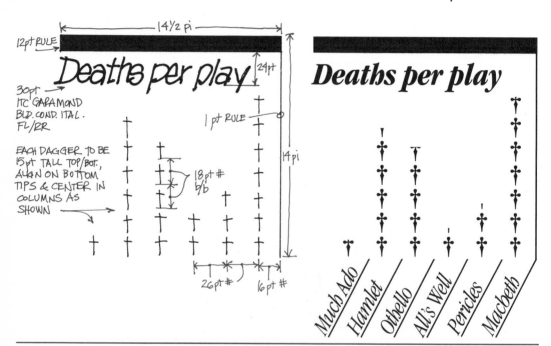

12pt RULE

├── 14½ pi ──┤

Deaths per play ← 24pt

30pt →
ITC GARAMOND
BLD. COND. ITAL.
FL/RR

1 pt RULE

EACH DAGGER TO BE
15pt TALL TOP/BOT.,
ALIGN ON BOTTOM
TIPS & CENTER IN
COLUMNS AS
SHOWN →

18 pt #
b/b

14 pi

26pt # 16 pt #

Deaths per play

Much Ado Hamlet Othello All's Well Pericles Macbeth

The dagger can be a symbolic element. Here it represents an idea that is natural to its image: deaths per play. To create partial daggers, full daggers must be cut off on the mechanical.

100

A dagger can be used as an illustrative element in a chart. Because it is frequently used to signal a footnote on a page, the dagger is commonly available in type fonts. Spec daggers in a specific font and size, using a sample book for reference. These daggers are specified at 18 points to fit a given height.

Even digital typesetting equipment is unable to set type on an angle, so the names along the bottom of the figure are set separately with an underscore 2 points below the baseline of each

name, then cut apart and pasted onto the mechanical.

When using typographic elements to make up a chart or graph—such as these daggers—be sure that the characters are set tight enough so that the column or row appears as a single, continuous unit.

Thumbnail

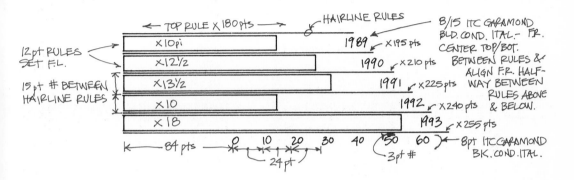

Diagonal charts and graphs must be set horizontally. Because the ends are trimmed anyway, it is easiest for the typesetter to set all rules flush left. The 45-degree angles are then cut on the mechanical. Indicate all spacing requirements between elements.

101

This is the most complex chart in the book. Although the chart is to be laid out on a 45-degree angle, the type must be set horizontally. (Remember, typesetting equipment cannot set type on the diagonal.) Therefore, the l2-point rules are set horizontally, then positioned and trimmed on the mechanical to achieve a 45-degree angle. The quarter-point (called **hairline**) rules are set in increasing 15-point increments.

The l2-point rules and the hairlines are set flush left so that trimming the left edge is simple. Starting from the end of the first hairline rule, cut a clean line with a 45-degree triangle. Then go back and trim the right end of each l2-point rule to correct the length. Best results are achieved if the cuts are made only through the emulsion (topmost) layer of the typeset paper, reducing the chance of cut lines showing in reproduction.

Tip the figure sideways for reproduction.

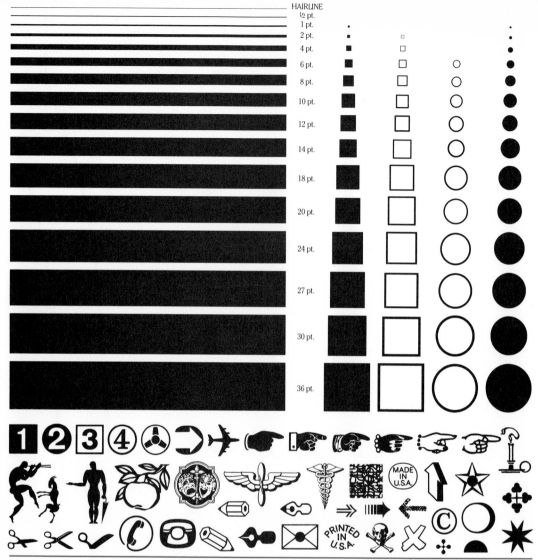

HAIRLINE	
½ pt.	
1 pt.	
2 pt.	
4 pt.	
6 pt.	
8 pt.	
10 pt.	
12 pt.	
14 pt.	
18 pt.	
20 pt.	
24 pt.	
27 pt.	
30 pt.	
36 pt.	

☞ The symbol that leads off this caption is a printer's fist, one of many dingbats available. Rules can be set vertically or horizontally in ⅛-point increments. Bullets and ballots (the square ones) are available in ½-point increments.

102 | RULES AND BULLETS

Rules and bullets are tools used to create visual emphasis, to attract attention, and to add color and interest to the page.

Rules can be set horizontally and vertically in a range of widths, from quarter-point (hairline) through 72 points, in ⅛-point increments.

Bullets are round shapes, solid or hollow. **Ballots**—sometimes called square bullets—are square shapes, solid or hollow. Both bullets and ballots come in a full range of sizes from 1 through 72 points.

Dingbats are ornamental designs that perform very much like bullets. They call our attention to a spot on the page. It is often more interesting to use a dingbat instead of a bullet, because you can select a dingbat that relates to the subject of the text.

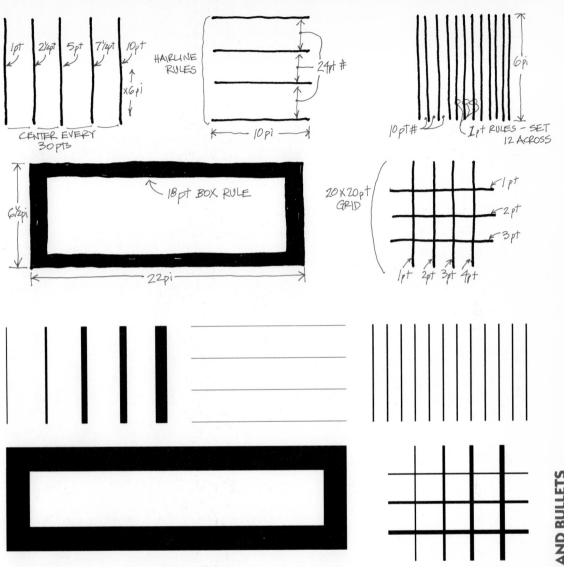

Weight and length are the only specs necessary for setting rules. Boxes and grids are set with true horizontal and vertical rules and have clean, square corners.

When specifying rules and box rules, indicate their length(s) and weight(s); for example, "10 point rule × 6 picas" or "18 point box rule × 6½ picas and 22 picas," as shown in the two examples above.

Current digitized typesetting equipment can create boxes and grids automatically with any rule weights you specify. On traditional phototypesetting equipment, horizontal rules are easy to set,

while vertical rules are more difficult. Boxes and crossing lines in grids can be done, but with these traditional means they tend to be expensive.

It is better to have rules set in type than to place tape or rub-down rules on the board. Typeset rules don't have to be mitered by hand to make 90-degree corners, and they have no sticky edges to attract fuzzballs to the mechanical.

Thumbnail

12/12 × 13½ JUST.
ITC QUORUM BK.

8pt SOLID BULLETS

INDENT TURNOVERS
TO ALIGN F.L. WITH
BULLETED TEXT.

from time to time I have acquainted you with the dear love I bear
to fair Anne Page, who mutually hath answer'd my affection. So far
forth as herself might be her chooser, even to my wish:
* I have a letter from her;
* fat Falstaff hath a great scene, the image of the jest I'll show
you here at large;
* he hath commanded her.
Now, her mother hath appointed that he shall likewise shuffle her
straight away. □ ← 6pt HOLLOW BALLOT, BASE-ALIGNED.

you with the dear love I bear to fair
Anne Page, who mutually hath
answer'd my affection. So far forth
as herself might be her chooser, even
to my wish:
- I have a letter from her;
- fat Falstaff hath a great scene, the
 image of the jest I'll show you
 here at large;
- he hath commanded her.
Now, her mother hath appointed
that he shall likewise shuffle her
straight away. □

Bullets should visually match the x-height of the type being used.
In this case, an 8-point bullet is used with 12-point type. The
9-point ballot matches the x-height of this type. Align all lines of
copy so that the bullets stand alone at the left edge of the column;
they are most visible that way.

104 Bullets are most frequently used to feature separated items in a list. Ballots often appear at the end of a magazine article to signal that the story has ended. Ballots can be used instead of bullets in a list if the reader is asked to check off items, perhaps, or to respond in some way to the entries.

Bullets should either match or be slightly smaller than the x-height of the type being used. It is necessary to refer to a typesetter's chart of bullets to select the appropriate size. An 11-point bullet is 11 points across, which will appear far too large for 11-point type, whose x-height may only be 6 or 7 points.

When setting a list that requires more than a single line for each item, indent turnovers (second lines of each item) so that all type aligns to the right of the bullets. The indent allows the bullets to hang out from the left edge of the copy, separating the listed items more visibly.

Come, night; come Romeo. Come, thou day in night; for thou wilt lie upon the wings of night whiter than new snow on a raven's back. Come, gentle night, come, loving, black-brow'd night. ⊛ Give me my Romeo and, when he shall die, take him and cut him out in little stars and he will make the face of heaven so fine that all the world will be in love with night and pay no worship to the garish sun. O,

Come, night; come Romeo. Come, thou day in night; for thou wilt lie upon the wings of night whiter than new snow on a raven's back. Come, gentle night, come, loving, black-brow'd night. ♥ Give me my Romeo and, when he shall die, take him and cut him out in little stars and he will make the face of heaven so fine that all the world will be in love with night and pay

Choosing an appropriate dingbat is an inexpensive and effective method of illustrating the text. Dingbats also add texture to the copy and attract attention. Unusual ornamental borders can be created by repeating dingbats. Because setting type sideways is difficult, the box must be set in four lines, cut apart, and pasted up on the mechanical.

Dingbats can be used in place of bullets. Like bullets, dingbats are used to attract the reader's attention, with an added benefit: you can select an image that lends unique character to the type or that relates in some way to the subject of the text. A heart is used above for a sentimental passage of text.

Dingbats are ordered by number in a wide variety of sizes from 6 to 72 points. Each type house has its own set of dingbats—and corresponding identification numbers—so ask for a catalog of dingbats, symbols, and ornaments.

Unusual borders can be created with repeated dingbats. Your design should be a little flexible in size, of course, in order not to chop any dingbats in half. When specifying dingbats for this purpose, indicate both the size of the dingbat and the amount of space (in points) between dingbats. Have the dingbats set in horizontal lines and arrange the lines in any configuration on the board.

"To succeed today, a graphic designer or art director must understand the melding of all phases of communications. He is a part of a total communications effort that starts, we hope, with a progressive client, an effective corporate image, and a knowledgeable product designer and ends in a consumer reaching into his pocket for money to buy that product. In between are the advertising copywriter, the art director, a packaging expert, point-of-sale and promotional people, and a dozen others. The problem has been that each person involved in the total communications effort thinks that his own thing is the key to marketing and selling that product. The "experts" within the communications pool just don't understand each other, and this causes a breakdown of communications between individuals who should not only have a thorough knowledge of each other's function but a respect for each other's contribution. Our success is due to the fact that we have made it our business to become knowledgeable in every area of communications. We know how important a good package design can be to the creators of effective advertising. If a stimulating ad gets a customer into a supermarket, a poorly designed package can quickly kill the sale no matter what the ad accomplished. And, conversely, a great package can make advertising look good. The day of specialists working in their vacuums is over. We predict that in ten years total communications teams within advertising agencies or retained by advertising agencies will take over all the functions—point of sale, display, packaging, product design, corporate design, architectural graphics, etc.—that were once farmed out to specialists and use their highly sophisticated methods to produce a much more effective marketing job for their customers. I have been doing a good deal of thinking about youth lately—youth in our business and youth as a consumer. I have reluctantly come to the conclusion that young designers today are so interested in getting rich quickly that they are not getting the background in all phases of communications and marketing, something that our field demands. On the other hand youth represents a gigantic buying public. Young adults comprise 35% of our population. We have to design for people 25 years old and under to sell. These young people are sharp, better educated than any other generation in the history of man. They are changing all the rules for successful selling. Look at what's happened in the last several years to men's clothing, in the automotive industry, and in the entertainment industry because of youth. Designers, too, must understand the changes that are taking place in society today and be able to respond creatively to them. We cannot settle for one font of wisdom just as we can't settle for one font of type. We must be creatures of the changing times. Communicators today are talking to themselves, holding monologues, when they should be holding dialogues. There is little room today for a narrow perspective on graphic design. In fact, design has been swallowed up by communications, and that's the world we are all working in today." The above statement and prediction were made by Herb Lubalin ten years ago, as president of the International Academy of Communicating Arts and Sciences. On Tuesday night, January 20, 1981, while the Reagans gussied themselves up for the Inauguration Ball...while the hostages sweated out their takeoff from Teheran...a few hundred fans, friends and family of Herb Lubalin tore themselves away from those TV spectacles to witness, in person, the presentation of the AIGA (American Institute of Graphic Arts) medal. For the Reagans, the Inauguration Ball was a definite "first." For the hostages, that day in Iran was a merciful "last." But for Lubalin, the award for excellence in graphics was number 573. Herb has become something of a Pied Piper to the young and a leader among his peers. It is especially to the young designers and students that this profile is directed, to reveal that there are really no gods...no supermen...no lucky Larrys in this business. But once in a while a little guy comes along with a few extra creases in his brain (which makes him see things in a unique way) and with a prodigious appetite for work. The consensus is that Herb is small, lean, elfin, prematurely white-haired and deafeningly silent. He's a bare 5 ft., 7 inches tall (he carries his head tucked into his shoulders which robs him of an inch or two); he weighs in at less than 140 lbs. He doesn't really walk; he shuffles. He doesn't really talk; he grunts, snorts, clears his throat a lot and occasionally nods his head. He's a conscientiously casual dresser, concentrating on subtle taupes, greens, grays and earth tones, guided by either a rare color sense or his congenital color-blindness. He's a sharp shot at tennis, skillful at ping-pong, a graceful swimmer, a smooth dancer, a reluctant walker—he does none of these things "briskly." He churns out mountains of work without ever looking ruffled, frantic or hurried. In fact, the only part of his body that really moves fast is his brain. It's clear, Lubalin's talent is unique. You can't learn it in school, from texts or even by swallowing whole issues of U&lc. He has a special radar for zooming in on a problem. He trims away the fat—the extraneous—and works out solutions that are succinct, witty and elegant. Though he has handled every design problem from letterheads to a loft interior, over the years he has been inextricably seduced by typography and letter forms. This man who hardly speaks is a language lover. There's nothing new about literary people playing with words that sound like what they mean, i.e., screech, scratch, grizzly, clang, whisper...but when Herb started to make words look like what they mean, it was the beginning of a whole new adventure in graphic design. His visualization of the word Marriage, with the double R's facing each other; his Mother & Child, with the ampersand and child nestled in the O, are the epitome of his wit. His solutions are so obviously right, they stun us. Herb is exasperating to people who produce work for him but never know what he thinks of their efforts. He is crushing to young designers and students who labor over a portfolio, seeking a serious critique, but hear only a few grunts, a mumble and a snort or two. If only they knew that a grunt, a snort and a little nod of the head from Herb can be thunderous applause. He can be a joy to work for. He is explicit, decisive and not given to endless revises; but he is stubborn to the extreme; his tenacity has driven others to rage and resignation. As for his quickie decisions, at least two now-famous graphic artists have the distinction of having been "fired" by Lubalin. People who know the meaning of "blocked" watch him work with envy and murder in their hearts. His powers of concentration are legendary. I've personally seen him—with tracing pad balanced on his knees, with football noises blasting from the TV set, with children wrestling underfoot, with food passing overhead—implacably reel off tissues with the regularity of copies shooting out of a word processor. Before the Giants have made a first down, he has 15 solutions to a graphic problem. And he has crumpled up more good ideas than most people produce in a lifetime of trying hard. He has no empathy for procrastinators, worriers or deliberators. What might be a "big deal" to the rest of us is a flash decision for him. Herb has bought houses, formed partnerships, entered into business ventures in less time than most people take to decide on a pair of shoes. That's unnerving. Expect no flood of compassion from him, not even a trickle, for your personal woes. You want to discuss a love affair, your children, your professional crises, your doubts, your fears, your psyche? Don't come to Herb. The whole Freudian mystique has passed him by. He has no use for psychology except, typographically, it has terrific potential—those ascenders, descenders and o's! But Herb is exasperatingly consistent; he keeps his own personal traumas and tragedies firmly locked behind the sluice gates, too. Contrary to all that has been made of his silence at work and in his private world, Herb does talk. Dress him in a tuxedo, stand him before a microphone, he sharpens up his everyday t's and d's and becomes a veritable Demosthenes—only funnier. Herb has lectured widely in the States, in Canada, Europe and Japan, informing and entertaining professionals and students with his devastating candor and humor. Or...if you should happen to touch on a topic that nettles him he will open up and deliver a diatribe he's had stored up for months. In his work he is loose and open. He has no hoked-up philosophies, no rigid imperatives. But in personal matters, he's a crazy aesthetic fanatic. He operates from a code of decency few people understand: He was an "equal-opportunity-employer" long before those words were invented. He hired women designers, artists and administrators before any one of them had her consciousness raised. He initiated the Ms. section of U&lc as a showcase for women in graphics. But don't, unless you enjoy severe indigestion, get him started on Women's Lib in the midst of a nice quiet dinner. To sum up, Herb Lubalin is: a brilliant communicator and non-communicative...an iconoclast and a classicist...esoteric and earthy...uptight and casual...worldly and provincial...turned off and turned on...unyielding and a pushover...embarrassed by small talk and poised on the podium...a lousy conversationalist and a great fishing partner...completely unpretentious...fiercely ethical...fiercely competitive...expensive...expansive...exasperating...stimulating...concerned...a pleasure to work with...laconic...left-handed...funny...and lovable.

mjb Typography

This example of painting with type is an extraordinary typographic configuration requiring consummate skill and artistic vision. Because it is necessary to pack the type tightly in order to see the image, there is very little space between the lines.

106 UNUSUAL CONFIGURATIONS

The "unusual configurations" in this section are typographic examples that don't fall into the other categories in this book.

This portrait of Herb Lubalin, one of the great graphic designers of the twentieth century, is an extraordinary piece of creative typography. First, the copy was set entirely in medium weight. In five successive passes of typesetting, different areas were replaced with light and boldface type until the portrait became visible.

For the first pass, only the overall column width, point size, and leading were specified. Best results are achieved if the type is packed tightly. In this example (which has been reduced for reproduction), the type was set minus-leaded 1 point (12/11).

Lord Abergavenny

20 pt ITC GALLIARD ROMAN

Lord Abergavenny

20 pt ITC GALLIARD ITALIC

Lord Abergavenny

ROMAN ITALICIZED

Lord Abergavenny

10% CONDENSED

Lord Abergavenny

20% CONDENSED

Lord Abergavenny

30% CONDENSED

Lord Abergavenny

40% CONDENSED

Lord Abergavenny

50% CONDENSED

Lord Abergavenny

10% EXPANDED

Lord Abergavenny

20% EXPANDED

Lord Abergavenny

30% EXPANDED

Lord Abergavenny

40% EXPANDED

Lord Abergavenny

50% EXPANDED

ʎuuǝʌɐƃɹǝq∀ pɹo˥

WRONG READING

Lord Abergavenny

REVERSE VIDEO

Speccing these modifications is very simple. In addition to your regular specs, just add the treatment you want; for example, "20 point ITC Galliard Roman, condensed 20%."

DIGITAL MODIFICATION

Digitized typesetting equipment can perform remarkable feats. Letter and line spacing can be inserted in ⅛-point increments. The equipment can also modify the characters themselves. For example, the 20-point Galliard Roman shown above has been manipulated to italic, condensed, expanded, wrong reading, and reverse video.

Italicizing a roman face does not duplicate the true italic version of the same face, as you can see by comparing the two versions shown here.

The mechanical manipulation tends to create distortions that are less appealing than real italics.

Distortions are also created when type is digitally expanded or condensed. It is advisable to use this application for headlines only, where you may want to adjust the type to fit a precise space. Avoid modifying type characters in text sizes where legibility will be impaired by the distortions.

William Shakespeare

Original type

William **Shakespeare**

Wedge, vanishing point left

William Shakespeare

William Shakespeare

Waves

WilliamShakespeare William Shakespeare

Spiral

William Shakespeare

Curves

Eastern Typesetting Company South Windsor, Connecticut

108 TYPOGRAPHIC DISTORTION

Some type houses have the facilities to create the effects on this and on the facing page. With specialized equipment, type can be modified to nearly any shape or configuration. Here are some basic themes.

Always start with a good, accurate comp of the design. The supplier will set the type to an appropriate size, then distort it to match the

design on your comp. Written instructions can be misleading if they are not bolstered by a clear visual reference.

These techniques are highly dramatic when applied to display type, hand lettering, artwork, and logos. They tend, however, to take text type very near illegibility. Use with caution below 18 point.

William Shakespeare

Arc

William Shakespeare

Stretch/Condense

William *Shakespeare*

Back slant/Italic

William Shakespeare

William Shakespeare

Outline

William
Shakespeare

Circle (tapered characters)

William Shakespeare

Shadow

This equipment also permits you to arc letters in any way you choose. You can have the characters distorted in both length and height to create an arc. Full circles can be created without letter distortion, the spaces between the letters being greater at the top than at the bottom. Or you can request that the letters be tapered, with the spaces between letters consistent from top to bottom (shown bottom left).

Letters can be reproportioned up to four times their original size. Spec the height of the let-

ter (in points or inches) and the width (in picas or inches). For example, you might want a single word (original size ½ inch × 13 picas) distorted to a height of ½ inch and a width of 34 picas.

You can request single or multiple outlines around letters in any line thickness. Even shadows around letters can easily be obtained. Specify the angle of the shadow desired according to the readings of a clock. (A five o'clock shadow is shown above.)

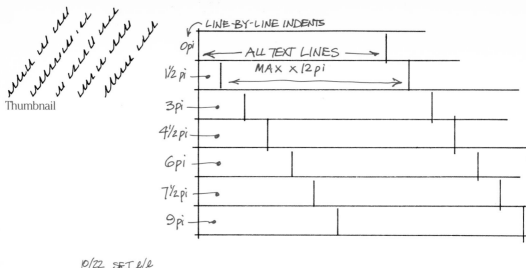

Thumbnail

LINE-BY-LINE INDENTS

0pi		← ALL TEXT LINES →
1½ pi		MAX x 12pi
3pi		
4½ pi		
6pi		
7½ pi		
9 pi		

10/22 SET l/l
ITC ZAPF CHANCERY
MED. – F.L/RR.
INDENT EACH
LINE PER
LAYOUT

```
         [Out, damned spot! out, I say! one: two:⌐
1½pi→why, then 'tis time to do't.  Hell is murky!⌐
 3pi→Fie, my lord, fie!  A soldier, and afeard?⌐
4½pi→What need we fear who knows it, when⌐
 6pi→none can call our power to account?⌐
7½pi→Yet who would have thought the old man⌐
 9 pi→to have had so much blood in him.⌐
```

When setting type for diagonal positioning, the key is to have consistently increasing line indentations. A simple sketch must be made, with line spacing indicated and correctly angled baselines drawn.

110 DIAGONAL BASELINES

Type cannot be set on a diagonal. In order to achieve a diagonal configuration, have the type set with horizontal baselines, but specify an indent for each new line. The greater the indent, the more acutely angled the type will ultimately be. Specify indents in points, picas, or ems, and increase the indents in consistent multiples, so that the left edge of type will be even. (Above, for example, the indents are marked in increments of 1½ picas.)

After the type is set, tip it sideways on the board.

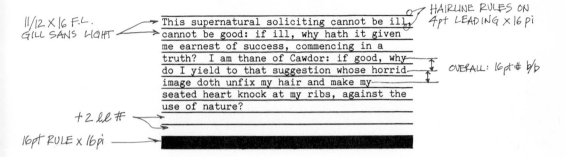

Thumbnail

11/12 × 16 F.L.
GILL SANS LIGHT

This supernatural soliciting cannot be ill,
cannot be good: if ill, why hath it given
me earnest of success, commencing in a
truth? I am thane of Cawdor: if good, why
do I yield to that suggestion whose horrid
image doth unfix my hair and make my
seated heart knock at my ribs, against the
use of nature?

HAIRLINE RULES ON
4pt LEADING × 16 pi

OVERALL: 16pt # b/b

+2 ll #

16pt RULE × 16 pi

This supernatural soliciting cannot be ill, cannot
be good: if ill, why hath it given me earnest of
success, commencing in a truth? I am thane of
Cawdor: if good, why do I yield to that sugges-
tion whose horrid image doth unfix my hair
and make my seated heart knock at my ribs,
against the use of nature?

To set type between rules, spec the baseline-to-
baseline distance for type-to-rule and rule-to-type
dimensions. The lines of type shown in this example
have an overall b/b of 16 points.

TYPE BETWEEN RULES

When setting type between horizontal rules, it is
necessary to remember that type specs always
measure from one baseline to the immediately
previous baseline. Rules, too, sit on baselines, so
in this example, specs must be given for both
type-to-rule and rule-to-type dimensions.

To determine equal space above and below
the type, deduct the actual cap height from the
vertical rule-to-rule space. In this example, the
11-point typeface has a cap height of 8 points,

there are 16 points of space from rule to rule, so
we deduct 8 from 16 to get 8 points of space dis-
tributed in equal 4-point portions above and
below the type.

This type is specified as 11/12 and the rules
are specified as hairline on 4 points of leading
(12 + 4 = 16 points overall b/b). The effect, then,
is that the type is set 11/16 with hairline rules cen-
tered in the space between the lines of type.

Thumbnail

Thumbnail

Handwritten annotations (left margin):

NO 9 INDENTS:
10/10 × 9 JUST.
ITC FENICE LT.
INDENT 1st ℓ X 6pi
" 2ND ℓ X 4 pi
" 3rd ℓ X 2 pi
" 4th ℓ X 0 pi
REPEAT CYCLE
ON 5th ℓ PER
THUMBNAIL

Annotations above text: 4 pt # 10 pt E3 DINGBAT

Most probable that so she died; for her physician tells me she hath pursued conclusions infinite of easy ways to die. Take up her bed, and bear her women from the monument. ▼

She shall be buried by her Antony: no grave upon the earth shall clip in it a pair so famous. High events as these strike those that make them, and their story is no less in pity than his glory which brought them to be lamented. Our army shall in solemn show attend his funeral, and then to Rome. Come, Dolabella, see high order in this great solemnity.

Most probable that so she
died; for her physician tells me
she hath pursued conclusions
infinite of easy ways to die.
Take up her bed, and bear her
women from the monu-
ment. ▼ She shall be buried
by her Antony: no grave upon
the earth shall clip in it a pair
so famous. High events as
these strike those that make
them, and their story is no less
in pity than his glory which
brought them to be lamented.
Our army shall in solemn show
attend his funeral, and then to
Rome. Come, Dolabella, see
high order in this great solemnity.

In this example of continuous-text paragraphing, a symbol is used to represent the beginning of a new idea. Because each line of type is exactly 9 picas wide (set justified), the shape of the column is visible on both its left and right edges.

112 UNUSUAL COLUMN STRUCTURE

This example combines an unusual column structure with paragraphs run in as continuous text but separated by dingbats.

The text is merely a series of equally long justified lines indented in a series of steps. Since every line is set justified to exactly the same length, the overall shape of the column becomes clearly visible. The first line is indented 6 picas, the second 4 picas, the third 2 picas, the fourth is not indented at all. At the fifth line, the cycle begins over.

The text runs continuously so that the shape of the column remains uninterrupted. Dingbats are inserted to indicate new paragraphs.

This arrangement is not easy to read and therefore should not be used for long blocks of text. It could, however, be appropriate for captions in a special report.

Figure 1
Thumbnails

Figure 2

Figure 1
9/14 × 10 JUST.
OPTIMA BOLD
SET EVERY OTHER
LINE 2 EMS TO RT.

[The king's a beggar, now the play is done. All is well ended, if
this suit be won, that you express content, which we will pay with
strife to please you, day exceeding day. Ours be your patience then,
and yours our parts; your gentle hands lend us, and take our hearts

Figure 2
8/24 × 10 JUST.
OPTIMA ITAL:
SKIP EVERY OTHER
LINE & INSERT

[It rested in your grace to unloose this tied-up justice when you pleased.
And it in you more dreadful would have seem'd than in Lord Angelo.

10/24 × 14 JUST.
OPTIMA ITAL:
INDENT EACH LINE
5 pi & SKIP EVERY
OTHER LINE FOR 8pt
TYPE PER THUMBNAIL

[I do fear, too dreadful. Sith 'twas my fault to give the people scope,
'twould be my tyranny to strike and gall them for what I bid them
do. For we bid this be done, when evil deeds have their permissive
pass and not the punishment. Therefore indeed, my father, I have on

The king's a beggar, now the
play is done. All is well ended, if
this suit be won, that you ex-
press content, which we will
pay with strife to please you,
day exceeding day. Ours be
your patience then, and yours
our parts; your gentle hands

It rested in your grace to unloose this
I do fear, too dreadful. Sith 'twas my fault to
tied-up justice when you pleased.
give the people scope, 'twould be my tyr-
And it in you more dreadful would
anny to strike and gall them for what I bid
have seem'd than in Lord Angelo.
them do. For we bid this be done, when evil

deeds have their permissive pass and not

Figure 1 is set with justified line lengths to create a similar shape on both edges of the column.

Figure 2 shows two columns of justified line lengths shuffled together. To achieve these results, both columns must share the same leading—much like setting type with rules.

JUSTIFIED LINE LENGTHS

Figure 1 is set in 10-pica justified line lengths with every second line indented 2 ems. Because the lines are short and the type is justified, the type size is small so that there will be enough characters on each line to avoid excessively open word spacing.

Figure 2 shows two columns of type shuffled together like playing cards. The two columns are of different widths and use different type sizes; one is text and the other a caption. To spec this, keep the leading the same for both blocks of copy. The type's baselines occur every 12 points where the two areas of type overlap. So spec the type 8/24 and 10/24 with the instruction to skip every other line and insert a line of the opposing text. Then spec the amount of indentation for the lines of text in the right-hand copy block.

NOTE: ALL TYPE IS ITC BENGUIAT CONDENSED.

14/14 BK,
CENTERED

ALIGN TOPS

6pt #

28/21 BOLD,
CENTERED

THE
GLOBE
THEATRE

PROPS
REPORT

STRATFORD
UPON
AVON

14/14 BK,
CENTERED

3pt SPACE

ALIGN
BOTTOMS

CHECKED BY: DATE:

PART NUMBER:

THE
GLOBE
THEATRE

PROPS
REPORT

STRATFORD
UPON
AVON

CHECKED BY: DATE:

PART NUMBER:

Thumbnail

THE
GLOBE
THEATRE

**PROPS
REPORT**

STRATFORD
UPON
AVON

CHECKED BY: DATE:

PART NUMBER:

Aligning the heights of two- and three-line headlines requires an overall height in points divisible by factors of both 2 and 3. The space for the headlines in this figure is 42 points high. The type in the two-line head will be set with 21-point line spacing; the three-line heads will first be set with 14-point line spacing, ready for final adjustment by hand. After determining the leading, trace type samples until you get a good match in type size and leading. If the heads are all caps, you may use minus leading (the type size will be greater than the line spacing designation).

114 HEIGHT ALIGNMENTS

This form is discussed on page 92, but without instructions on how to spec the heads. The challenge here is to align the top and base of the words *Props Report* with the tops and bases of *The Globe Theatre* and *Stratford Upon Avon.*

Think of the depth occupied by all three headlines as a single space, measured in points. In this case, it is easier to have a space divisible by both 2 and 3 because there are two lines of type in the center column and three lines of type in each outside column. The example's depth is 42 points because 42 can be divided into two units of 21 points and three units of 14 points. These will be the b/b specs for the first pass. You will probably need to adjust with a razor blade to get it perfect because the height of the caps varies from face to face.

For the center column, the type is specified 28/21; for the outside columns, 14/14. The type sizes are determined by tracing from a type sample book.

Thumbnail

In this example, ¾-point box rules and centered 36-point initial caps are combined with laser-printed computer artwork.

INTEGRATED BOX RULES

These initial caps can be set in position within the box rules. Because the copy is so brief, the initial caps are specified on the comp drawing.

The ¾-point rules are positioned to make three boxes of 7 picas square, butting to an overall width of 21 picas. The inset square of 3½ picas butts against the left and top rules within each of the larger squares.

The initial caps were specified in 36-point Palatino Italic caps, centered within each of the three small boxes. The heart illustrations, which were drawn with a computer and laser-printed, were placed on an acetate overlay on the mechanical.

Globe Theatre,
WILLIAM SHAKESPEARE

Thumbnail

14pt CLOISTER BLACK SET TWICE: POSITIVE & REVERSE VIDEO — MATCH LET & WORD SPACING!

12pt RULE X WIDTH OF TYPE BELOW

Globe Theatre

36pt FUTURA EX.BLK.COND. CAPS— SET TIGHT:NOT·TOUCHING

WILLIAM SHAKESPEARE

2 pt #

2pt RULE X WIDTH OF TYPE ABOVE

Globe Theatre
WILLIAM SHAKESPEARE

Globe Theatre was set twice—normally and in reverse video—then spliced together to create the final artwork as it appears here. Overall width of the artwork was determined by the typesetter, based on the 36-point Futura setting.

116 SPLIT REVERSE VIDEO

To reverse the type on the lower half of the words *Globe Theatre*, the type was set twice: once normally and once in reverse video. The two pieces were carefully butted on the mechanical, creating the split phrase as it appears in the final version here. The 12-point rule was set above *William Shakespeare* so that the ends would be square. The reverse video part of *Globe Theatre* was pasted directly on top of the center section of the rule.

Notice that the specs contain specific instructions to match letter and word spacing in both settings of *Globe Theatre*. Reverse video setting adds a little extra letter and word space, so it is advisable to alert the typesetter to match the spacing in both versions. This will be done by opening up the normal setting to match the reverse video.

1

11/12 × 10
JUST.
ITC GALLIARD
ROMAN
INDENT 1st
4 ll × 4 pi

72 pt BOLD DROP CAP – BASE ALIGN WITH 4th l OF TEXT, HANG SERIFS ON LEFT EDGE.

Round-hoof'd, short-jointed, fetlocks shag and long, broad breast, full eye, small head and nostril wide, high crest, short ears, straight legs and passing strong, thin mane, thick tail, broad buttock and tender hide. Look, what a horse should have he did not lack, save a proud rider on so proud a back.

2 Sometime he scuds far off and there he stares; anon he starts at stirring of a feather; to bid the wind a base he now prepares, and whether he run or fly they know not whether. For through his mane and tail the high wind sings, fanning the hairs, who wave like feather'd

2

9/12 × 7
FL/RR
ITC GALLIARD
ROMAN

60 pt BLD. HANGING INITIAL – ALIGN TOP WITH ASCENDERS, 12 pt UNDERSCORE × CAP WIDTH 2 pt BELOW.

Round-hoof'd, short-jointed, fetlocks shag and long, broad breast, full eye, small head and nostril wide, high crest, short ears, straight legs and passing strong, thin mane, thick tail, broad buttock and tender hide. Look, what a horse should have he did not lack, save a proud rider on so proud a back.

3 Sometime he scuds far off and there he stares; anon he starts at stirring of a feather; to bid the wind a base he now prepares, and whether he run or fly they know not whether. For through his mane and tail the high wind sings, fanning the hairs, who wave like feather'd

3

11/12 ITC
GALLIARD
ITALIC:
JUST. LINES
1,3,5,7 – ×
18 pi &
JUST. LINES
2,4,6,8 ×
16 pi.
ALIGN ON
LEFT EDGE.

When my love swears that she is made of truth I do believe her, though I know she lies, that she might think me some untutor'd youth, unlearned in the world's false subtleties. Thus vainly thinking that she thinks me young, although she knows my days are past the best, simply I credit her false-speaking tongue. On both sides thus is simple truth suppress'd. But wherefore says she not she is unjust? And wherefore say not I that I am old? O, love's best habit is in seeming trust, and age in love loves not to have years told: therefore I lie with her and she with me, and in our faults by lies we flatter'd be.

4

A B C D E F G H I J

EXERCISES

These exercises will help you develop your skills in copyfitting and marking up the manuscript for two initial caps (Figures 1 and 2), an unusual text configuration (Figure 3), and a chart (Figure 4).

Comp Figures 1, 2, and 3 based on the type specs shown. The comps should be presentation quality.

Trace Figure 4 and indicate all specs needed to get the typeset results shown. (The type used is ITC Galliard Bold.)

Answers can be found on page 119 – but don't peek.

Answers to exercises on page 43:

1 2 points of leading
(11/13)

2 7½ inches or 45 picas deep

3 2,025 manuscript characters

4 84 total lines of set type
(28 lines per column)

5 1,978 set characters

6 274 words (1,367 characters)

44.1 ch/line × 31 lines = 1,367.1 set characters
1,367.1 characters ÷ 5 ch/word = 273.4 words
Round up to 274 words

7 21 lines and 2 points of leading
(10/12)

1

R

2

R

3

4

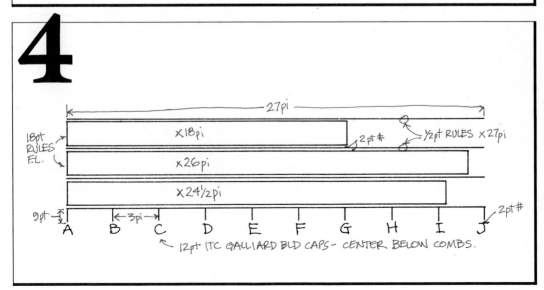

27pi

x18pi 2pt # 1/2pt RULES x27pi

18pt
RULES
FL.

x26pi

x241/2pi

9pt 3pi

A B C D E F G H I J 2pt #

12pt ITC GALLIARD BLD CAPS — CENTER BELOW COMBS.

AA *Author's alteration,* a change in text after it has been set in type.

Agate A unit of measurement used in newspapers to measure column depth. There are 14 agate lines in 1 inch.

Alphabet length The measurement, in points or picas, of the lowercase alphabet of a specific typeface and size.

Ampersand A symbol developed from the Latin *et,* meaning *and.*

Ascender The part of a lowercase letter that extends above the mean line, or top of the x-height.

Asymmetrical A typographic arrangement in which the left and right edges of the column are not in a recognizable relationship with each other.

Ballot A square bullet, so named because, being square, it is sometimes used to receive a check-marked vote.

Baseline The imaginary line on which letters rest. Descenders hang below the baseline.

Body type 6- to 14-point type used for lengthy text composition. Also called text type.

Boldface A heavier version of the normal weight of a typeface.

Breaking for sense Breaking lines of copy into phrases so the meaning is clear.

Bullet A dot, which can be any size, used as a decorative or organizing device.

Cap height The height of a capital letter from the baseline to the top of the letter.

Caption The explanatory text accompanying a photo or illustration. Usually set smaller than the text. Also called a *legend* or *cut line.*

Casting off A type-speccing process in which the characters-per-pica figure is divided into the total character count of the manuscript. The result is the number of lines of set type.

Centered A typographic arrangement in which the left and right edges of the column are mirror images of each other.

Character count The total number of characters, including word spaces, in a piece of copy.

Characters Individual letters, numerals, punctuation, and so on.

Characters per pica The average number of characters in a given size of a typeface that will fit into 1 pica of horizontal space. Used as a means of determining the length of copy when set in type.

Chart A pictorial image representing quantifiable relationships. *See* Graph.

Color The relative lightness or darkness of an area of type.

Column inch A newspaper measurement designating a space one column wide by 1 inch deep.

Column width The measurement from the left to the right side of a group of lines of set type.

Combs Vertical hashmarks on horizontal rules used as slots for adding information to a form.

Comp A tight rendering of a layout or design accurately indicating the relationships among all elements.

Condensed A narrower version of the normal width of a typeface.

Copy In design and typesetting: manuscript type. In printing: all material to be printed (type, illustrations, photos, etc.).

Copyfitting The process of estimating the amount of space typewritten copy will occupy when it is set in type.

Descender The part of a lowercase letter that hangs below the baseline, or base of the x-height.

Dingbat An ornamental symbol or design used to get attention.

Display type Type intended to catch attention and generate viewer reaction. Generally 18 points and larger.

Drop paragraph A paragraph that begins immediately below the period ending the preceding paragraph.

Em A square of the point size of the type being used. Used in indentations and word spacing, an em in 6-point type is 6 points wide by 6 points high; whereas an em in 8-point type is 8 points wide by 8 points high.

En Half the width of an em. An em in 6-point type is 3 points wide by 6 points high.

Expanded. A wider version of the normal width of a typeface.

Extract A lengthy quote taken from another source. Set across a narrower column and in a smaller type size than the surrounding text.

Flush Even, or aligned, on one edge. This term may be applied to the alignment of any element in a design, although it most often is used in reference to lines of type.

Folio A page number. Odd numbers are right-hand pages; even numbers, left-hand pages.

Font One size and design of a given type style, including caps and lowercase letters, numerals, fractions, accented characters, punctuation, bullets, and symbols.

Foot margin The white space at the bottom of a page.

Form A document with blanks for the insertion of information.

Graph A pictorial image representing quantifiable relationships. *See* Chart.

Gutter The area where two pages of a publication join at the binding edge.

Hairline rule A ¼-point rule.

Hanging initial An initial placed in the margin to the left of the text.

Headline Prominent display type meant to summarize the accompanying copy and attract attention.

Head margin The white space at the top of a page.

Hung punctuation Punctuation set in the margin to achieve an optically flush edge.

Indentation The space inserted at the beginning of a line of type. In paragraphing, it is used to indicate the beginning of a new idea.

Initial cap An enlarged letter at the beginning of a block of text.

Italic Type in which the letters are slanted to the right.

Justified type Lines of type that are all the same length. They are flush on both the left and right edges.

Kern To tighten up the space between two letters for optically consistent letterspacing.

Leaders Dots or dashes used to lead the eye across space, for example, from title to page number on the table of contents.

Leading Also written as *ledding*. *See* Line spacing.

Lead-in The first few words of copy set in italic, boldface, or all caps.

Letterspacing The spacing between individual letters.

Ligature Two or three characters linked to create a single letterform, for example ff, ffi, ffl.

Lightface A lighter version of a normal weight of any given typeface.

Line for line A spec that indicates copy is to be set as it is typed; the line breaks can be predetermined by the designer. This is necessary to "break for sense" (divide the copy into meaningful phrases).

Line spacing The spacing between lines of type, appearing between the bottoms of descenders and the tops of ascenders. Also known as *leading*.

Lining figures Numerals that are the same height as capital letters and align on the baseline. *See* Oldstyle figures.

Live area The printing area of the page contained within the margins.

Lowercase Small letters. When type was set in metal, these letters were stored in a drawer literally below the capital letters, or "upper case." Specify as *lc* or by making a slash through the letters to be set in lowercase.

Margins The nonprinting areas surrounding live area.

Mark up To write type specifications on a layout or typewritten manuscript.

Mean line The implied line at the top of the x-height.

Measure The length of the typeset lines; the same as the width of the column.

Mechanical The camera-ready assembly of typographic and illustrative elements and printer's instructions ready to be reproduced for printing.

Minus leading Setting type with less space from baseline to baseline than the type's size; the ascenders and descenders can overlap. An example of a spec for minus leading is 12/10.

Minus letterspacing Reducing the normal spacing between characters in a word.

Monospace A kind of typewriter that assigns all characters the same width of space, so an *i* is as wide as an *m*. *See* Variable space.

Oldstyle figures Numerals having ascenders and descenders. The body matches the x-height of the face. *See* Lining figures.

Optical alignment Adjustment of letters and other elements so they *appear* to be correctly aligned with one another.

Orphan A very short line ending a paragraph and carried over to the top of another column. *See* Widow.

Overscore A rule or line set above type. *See* Underscore.

Phototypesetting A typesetting method in which light-sensitive paper is exposed to negative letterforms on film, creating black characters on a white background.

Pica A unit of measurement equaling 12 points. There are 6 picas to an inch. *See* Points.

Pi characters Reference marks and symbols designed to match any other typefaces. Assembled in *pi fonts.*

Point The basic increment of typographic measurement. There are 12 points in a pica and 72 points in an inch.

Point size Generally, the size of type measured from the top of the ascenders to the bottom of the descenders; not, as is so often misunderstood, the height of the capital letters alone.

Posture The angle of stress of a typeface: roman (vertical), italic (oblique), back slant (oblique to left).

Ragged Multiple lines of type set with either the left or right edge uneven. Word spacing remains constant in ragged setting. Compare to flush, which is even along one edge, and justified, which is even on both edges.

Recto A right-hand page, odd numbered. *See* Verso.

Reverse video Digitally set white type on a black background.

Roman Type that has a vertical emphasis. Compare to italic or cursive.

Rough A quickly drawn, full-size representation of a visual idea.

Rough rag Ragged type set without hyphenation. Words that cannot fully fit on a line are carried down to the next, creating a strongly contrasting ragged edge. *See* Tight rag.

Rule A typographic line whose thickness is specified in points.

Runaround Type set to fit around another typographic or illustrative element, reflecting its contour.

Sans serif Type without serifs.

Serifs Feet at the ends of the main strokes of letters.

Small caps Capital letters designed to appear about the same size and color as the x-height of lowercase letters. Part of a complete text type font.

Spec book A collection of typefaces showing various sizes and styles of the fonts a typesetter has available, with figures for set characters per pica. A complete spec book also shows rules, bullets, and dingbats.

Stet A proofreader's mark indicating that copy marked for correction should revert to its original version.

Stress The direction of thickening in a curved stroke.

Subhead A secondary level of display type, usually located between the headline (primary typographic element) and the text.

Subscript A character that prints below the baseline of the type.

Superscript A character that prints above the mean line of the type.

Swash letters A character with flourishes.

Table A typographic display of data arranged in columns.

Terminal The end of a letter's stroke not ended with a serif.

Text type Copy that is smaller than display type. *See* Body type.

Texture The relative smoothness of an area of type. Determined by type posture, size, weight, leading, and column structure.

Tight rag Ragged type set with hyphens. Words that cannot fully fit on a line are broken by hyphenation and continued on the next line, creating a smoother ragged edge than a rough rag. *See* Rough rag.

Transfer type Letters on an acetate sheet that can be rubbed down or cut out.

Turnovers The second and all subsequent lines of headlines and bulleted items, indented a similar distance to the right of the bullet.

Typeface A named type design, such as Bodoni, Cheltenham, Futura.

Type family All the variations of a typeface designed with similar characteristics. Type families usually consist of the basic roman, italic, and bold variations. Enlarged type families include condensed, expanded, shaded, outline, and combinations of the above.

U/lc The abbreviation for *upper and lowercase,* a typesetting designation.

Underscore A rule or line set below the type. *See* Overscore.

Uppercase Capital letters. Specify as *UC* or *all caps* or underscore the letters or words to be set in caps with three lines. *See* Lowercase.

Variable space A kind of typewriter or electronic device that assigns each character individual spacing according to its specific shape. For example, an *i* is narrower than an *m.* *See* Monospace.

Verso A left-hand page, even numbered. *See* Recto.

Weight The relative thickness of a letter's strokes compared with its counters.

Widow A very short line ending a paragraph. *See* Orphan.

Word spacing The spacing between words.

x-height The height of lowercase letters excluding ascenders and descenders. It is limited by the baseline and the mean line.

⌐ Indent (or move to right)

⌊ No indent (or move to left)

⌋⌊ Center

◻ En

□ Em

⊞ 2 ems

③ 3 ems (number in box indicates number of ems)

Space

¶ Paragraph

⌐ Break line

ℓ Line

ℓℓ Lines

ℓ/ℓ Line-for-line

b/b Baseline-to-baseline

⌣ Close space

ↄ Transpose letters or words

𝒶 Delete

STET Ignore correction (or revert to previous correction)

TNT Tight-not-touching

DNS Do not set

⟫ Align

CAPS Caps

ℓ/c. Lowercase

U/lc Upper and lowercase

ITAL Italics

BF Boldface

American Institute of Graphic Arts. *Annuals.* New York: Watson-Guptill Publications.

Berryman, Gregg, *Notes on Graphic Design and Visual Communication.* Los Altos, CA: William Kaufmann, Inc., 1979.

Burns, Aaron. *Typography.* New York: Van Nostrand Reinhold, 1961.

Carter, Rob, Day, Ben and Meggs, Philip. *Typographic Design: Form and Communication.* New York: Van Nostrand Reinhold, 1985.

Clark, Charles H. *Idea Management: How to Motivate Creativity and Innovation.* New York: American Management Associations, 1980.

Craig, James. *Designing with Type,* Revised Edition. New York: Watson-Guptill Publications, 1980.

Communication Arts Magazine. Palo Alto, CA: Coyne & Blanchard, Inc.

Dair, Carl. *A Typographic Quest.* West Virginia Pulp and Paper Company, 1964-1968.

Gill, Bob. *Forget All the Rules About Graphic Design, Including the Ones in This Book.* New York: Watson-Guptill Publications, 1981.

Gold, Ed. *The Business of Graphic Design: A Sensible Approach.* New York: Watson-Guptill Publications, 1985.

Haley, Alan. *Phototypography: A Guide for In-House Typesetting.* New York: Charles Scribner's Sons, 1980.

Meggs, Philip B. *A History of Graphic Design.* New York: Van Nostrand Reinhold, 1983.

Morrison, Sean. *A Guide to Type Design.* Englewood Cliffs, NJ: Prentice-Hall, Inc., 1986.

Newcomb, John. *The Book of Graphic Problem-Solving.* New York: R.R. Bowker Company, 1984.

Print Magazine. New York: R.C. Publications, Inc.

Rehe, Rolf F. *Typography: How to Make It Most Legible.* Carmel, CA: Design Research International, 1974.

Romano, Frank J. *The TypEncyclopedia.* New York: R.R. Bowker Company, 1984.

Snyder, Gertrude and Peckolick, Alan. *Herb Lubalin: Art Director, Graphic Designer and Typographer.* New York: American Showcase, 1985.

Solomon, Martin. *The Art of Typography.* New York: Watson-Guptill Publications, 1986.

Step-by-Step Graphics Magazine. Peoria, IL: Dynamic Graphics, Inc.

Type Directors Club. *Annuals.* New York: Watson-Guptill Publications.

White, Jan V. *Editing by Design,* Second Edition. New York: R.R. Bowker Company, 1982.

_____ *Graphic Idea Notebook.* New York: Watson-Guptill Publications, 1980.

_____ *Mastering Graphics.* New York: R.R. Bowker Company, 1983.

_____ *Using Charts and Graphs.* New York: R.R. Bowker Company, 1984.

Young, James Webb. *A Technique for Producing Ideas.* Chicago: Crain Communications, 1975.